Praise for *Fro...*

"Taylor Markarian has such a unique voice and a keen understanding of the musical scenes she's been documenting during her writing career. It was only a matter of time before she told a larger story via a book format. I'll be reading cover to cover."

—Amy Sciarretto, Atom Splitter PR

"Taylor has not only been a part of meticulously documenting the history of emo with well-researched commentary and thoughtful interviews as a journalist, but has lived and breathed it as a passionate fan."

—Rabab Al-Sharif, executive editor of *Loudwire*

"She's a force of investigative passion. Weaving history with humor, she tracks down a genre and a generation with a tremendous amount of access—and who better to take us down into the basement of it all?"

—Danielle Barker, literary critic and scholar

"In just a few sentences, I found myself sucked in. I was suddenly emo's number one fan, and I just had to dive deeper into the genre's history. Taylor's passion for music immediately captivates you, and you don't want to leave until you've read everything she has to say."

—Brandon Ramos, social media director of Epitaph Records

FROM THE BASEMENT

FROM THE BASEMENT

A History of Emo Music and How It Changed Society

Taylor Markarian

TURNER
PUBLISHING COMPANY

Turner Publishing Company
Nashville, Tennessee
www.turnerpublishing.com

Copyright © 2019 by Taylor Markarian

From the Basement: A History of Emo Music and How It Changed Society

Photos by Taylor Markarian and Brian Froustet
Cover Design: Roberto Nunez
Layout Design: Jermaine Lau

Library of Congress Cataloging
ISBN: (p) 978-1-64250-114-8 (e) 978-1-64250-115-5

Library of Congress Control Number: 2019944220

BISAC category code: SOC002010 SOCIAL SCIENCE / Anthropology / Cultural & Social

Printed in the United States of America

This book is dedicated to anyone who needs it.

Foreword

By Natasha Van Duser
Music Journalist

There's something peculiar about growing up listening to the entire My Chemical Romance discography on repeat, wearing really dark, ripped clothing, and being told that this is probably just some rebellious phase. It's even more peculiar now that I'm an adult with two My Chemical Romance tattoos, a degree in punk rock history (yes, that's a thing), and a career that stemmed from loving to dissect the lyrics I devoured on the daily. My name is Natasha Van Duser. I'm a music journalist and a professional makeup artist—it's an odd combination, I know. But most subcultures of rock came to be because they were some sort of strange amalgamation of sound and attitude. Punk was abrasive but also insecure. Grunge found a way to be completely carefree while also being obsessive and introspective. And emo was sad but also incredibly uplifting. It was this bizarre mismatching of traits that made underground rock scenes flourish. It's what made them so unique and memorable to this day. And it's why there are countless retellings of rock's history from a variety of different angles, like Gillian McCain and Legs McNeil's *Please Kill Me*, Patti Smith's *Just Kids*, and even Chuck Klosterman's *Killing Yourself to Live*. There's a humanity to rock music that reads far more authentically when seen through the eyes of someone who experienced the lifestyle themselves rather than a bone-dry history—a factual regurgitation of hardcore would simply be missing the point of the movement entirely. So, when I heard

that Taylor Markarian was writing her own history of emo, I knew it would not only be told from all the right perspectives, but that it would also be as genuine as the scene itself.

I met Taylor when I was eighteen years old. We were at a really shitty party in a New York University dorm, and she walked in wearing a Motionless in White hoodie. I loved that band at the time and marched right up to her, red solo cup in hand, and said "I love Motionless in White!" She looked me up and down with a confused countenance I have yet to see since. I was wearing flip-flops, Hollister shorts, and a purple baby doll top I got from Pac Sun; at this point, I didn't have any of the tattoos that now cover the majority of my body. So, I started naming my favorite songs off of the band's debut album *Creatures* in response to her hesitation. I also believe I said something uber creepy along the lines of "We're going to be friends now!" But alas, from that day forward, Taylor Markarian became not only one of my best friends, but also one of the best coworkers I've ever had.

We would edit each other's college papers, share bands we both loved, and go to shows (we even threw our own basement shows). Down the road we would cofound the web publication *HXC Magazine* and write together for *Alternative Press* for a number of years. Eventually, my love for art and makeup drove me away from a full-time writing career, but Taylor's love of music journalism and history only got stronger. As of today, she's written for *Alt Press*, *Substream*, *Loudwire*, *Kerrang!*, *Revolver*, and a handful of other publications. She's been backstage with Hawthorne Heights, had coffee with Frank Iero, been in a Senses Fail music video, and chatted about tea with

Ian MacKaye. She's interviewed a plethora of musicians, written countless record reviews, and probably gone to more shows than she could name. But, most importantly, what qualifies Taylor to write this book more than anything else is that she was never an outsider looking in. Taylor grew up at the height of emo, embraced the culture she's speaking about, and now has the connections and skills to put down a basement history of a genre that was so much more than just a phase.

Emo is a music period that is still extremely relevant today, even though MySpace and the value of a CD have basically gone extinct. From local Emo Nights to modern hip-hop to fashion week runways, emo pokes its eyeliner-adorned head all throughout contemporary pop culture. And, while this book gives you a concise history told from the mouths and minds of the people who were there and the pivotal players that turned it into the monstrous boom that it became, there's also a sense of nostalgia that you can't quite escape. Within these words, you don't just get to hear about bands playing college cafeterias or insider studio sessions dissecting some of the most memorable lyrics. Instead, you get to feel as if you're there, right then. Reading this book will take you back to being a fifteen-year-old kid going to basement shows and summer festivals, screaming along with words you may or may not have tattooed on you now. Though the height of emo has had its heyday, the legacy it left behind is still standing strong, and this book is here to make sure everyone knows it.

SAT, NOV. 9
1996 AD
5:00PM

A VERY SPECIAL
BENEFIT $3.00

CLOCKWI

MILHOUSE

CLEANS

KILL YOUR IDOLS

insid

leech implant

the. COMMON
GROUND a.k.

CADGUN In the

SAT, NOV. 9
1996 AD
5:00PM

A VERY SPECIA
BENEFIT $3.00

CLOCKWI

MILHOUSE

CLEANSE

KILL YOUR IDOLS

insid

leech implant

the. COMMON
GROUND a.k.

Introduction

What the fuck is emo?

This is a question that many have agonized over and continue to agonize over. Most of the bands that have been canonized as emo don't claim the term and, even better, don't even know what it means. So how am I to write a complete and compelling history of emo music when half of the heroes of the genre spend their time pointing fingers at someone else and saying, "Our band wasn't emo, *that* band was emo"?

"You set yourself a challenging task," Chris Simpson, the vocalist and guitarist of Mineral, said to me.

Indeed I have, which is why what you are about to read is as much a comedy of errors as it is a serious attempt to encapsulate a time in rock history for posterity. But through all of this confusion, what I have concluded is that nobody can agree on one definition of emo because there is no single definition; rather, there are multiple.

The first wave of emo influencers in the mid 1980s and the bands that followed in the mid-to-late '90s weren't emo in the same way that mainstream music listeners think of bands such as My Chemical Romance, Fall Out Boy, or Panic! At the Disco (who are actually more alternative, pop rock, or indie in terms of sound). That's because the meaning of the word has shifted and has remained ambiguous over time. From Rites of Spring to The Promise Ring to American Football to Sunny Day Real Estate to Jimmy Eat World, the word "emo" has amassed quite a reputation. The soundscapes bands such as these

created the musical elements that would soon be classified as emo: personal and vulnerable lyrics, a combination of the edginess of punk and hardcore with pop sensibilities and catchy melodies, and variations in tone and tempo from slow, minimalistic, and melancholic to aggressive, upbeat, and whiny (in the best possible way, of course).

At the turn of the millennium, bands like Brand New and Taking Back Sunday took the basics of '90s emo and developed more of a flair for the dramatic. This new kind of emo developed a style, as does almost any genre, from hip-hop to heavy metal. Increasingly, emo became known as a fashion and lifestyle choice. The emphasis on this new visual aesthetic is what ultimately broke through to mainstream music and television. My Chemical Romance would become the poster boys for the mainstream's vision of emo, when, really, this was the turning point that many earlier emo bands point to as the downfall of the genre.

Then there is simply the word itself: "emo," short for "emotional." This may be the most confusing point of all, for what kind of decent music is not emotional? What kind of good jazz or punk or classical music does not make the listener feel something? Music is inherently emotional. Yet, there was something about this set of sounds and this set of bands during this set of years that warranted the name more than any other.

It is the purpose of this book to discover what that *something* is. What was it that made emo so popular, yet so open to ridicule? What was it about emo that had fans claiming it saved their lives? This book aims to give as extensive and thorough answers to these questions as possible. It also aims to make the point that this genre is worth such an effort to portray in its entirety, for there

are many who don't think emo is a substantial enough genre to earn a place in rock history. In fact, as I type this, spellcheck insists with its red dotted lines that there is no such word as "emo." So fuck whoever thinks they are too good for this. Fuck the pretentious critics and the computer software that don't recognize the emo movement and its significance.

Emo *is* significant. It is significant because of every girl in a Get Up Kids T-shirt and every boy who broke up with her. It is significant because of the bonds it made and the suicidal hands it stayed. It is significant not only for the way it sounded, but also for the way it made us feel. And ultimately, it is most significant to the current culture of openness about mental health, as it aids us to connect with one another at last.

$ 15.00 GEN ADM STANDING 15.0

6.25 WWW.STARLANDBALLROOM.CO

SECTION/AISLE

GA HAWTHORNE HEIGHTS

GA 5

ROW SEAT

GA+ 233 STARLAND BALLROOM

GKJ103A SAYREVILLE, NJ

22NOV05 SAT DEC 3, 2005 6:00PM

PV0814 GA GA0 296 J-TYP

EVENT CODE SECTION/AISLE ROW/BOX SEAT ADMISSION

$ 30.25 GEN ADMISSION 30.2

7.25 SAMSUNG & CINGULAR PRES

SECTION/AISLE

GA VANS WARPED TOUR '05

CA 46 * * * *

ROW SEAT

GA0 296 OLD BRIDGE RACEWAY PARK

ORJ104J ENGLISHTOWN, NJ

12AUG05 SUN AUG 14, 2005 DRS 11A

STANDING ONLY

BRAND NEW

EVENT CENTER

BORGATA CASINO, HOTEL AND SPA

Look Back & Laugh,
a.k.a. Where Emo Came From

When I was thirteen years old, my best friend's
older brother played in a band called Eastbound. The year
was 2006, and they were doing something no one else in
our quiet New Jersey suburb was doing. I had never heard
this kind of rock music before; it was fast and loud and
forceful, but it was also catchy, with a voice that sounded
almost gentle. When I saw them play a show for the
first time, I couldn't believe my eyes. Each member was
jumping and moving around the stage like they had never
had more fun in their lives. Even the drummer was barely
in his seat. They were opening themselves up completely
and unapologetically for everyone to see. I remember
thinking, "This is the coolest thing I have ever seen." I had
just begun to discover what this thing, that would later be
called "emo," really was.

Now, Eastbound wasn't emo per se, but they were
definitely influenced by bands that were, especially since
the siblings' cousin happened to be Matt Rubano, the then
bassist for the Long Island-based emo frontrunner, Taking
Back Sunday. The first TBS song they showed me was "A
Decade Under the Influence," which I then played over
and over again on my first generation green iPod Mini.
(Remember when iPods had black and white screens?)
Then they started telling me about other bands, such
as The Early November, Midtown, The Get Up Kids, and
Jimmy Eat World. From there, I began my own research
into screamo bands such as Senses Fail and Thursday and
plunged into the rabbit holes of Myspace, PureVolume,
and Limewire. It wasn't until much later, though, that I
realized that I was coming of age in a hot zone (a.k.a. the
Garden State) for what would ultimately be classified by
its proponents as a musical movement.

But emo didn't start with me and my story. In fact, many of the people I've interviewed say the first seeds of the genre were planted in the mid-to-late 1980s by Dischord Records bands such as Fugazi, Embrace, and Rites of Spring.

"The first wave of emo was born from hardcore and post-hardcore music," explains Ethan Fixell, US executive director of *Kerrang!*. "In 1985–86, you had DC Dischord bands like Rites of Spring, Embrace, Gray Matter, and Dag Nasty all coming from the hardcore scene and pushing the boundaries of what it meant to be a part of that world. Their music was slower, more melodic, and simply less aggressive than that which they'd been producing previously in bands like Minor Threat or S.O.A., for example."

"I grew up on Rites of Spring and Dag Nasty and Embrace," attests Eddie Reyes, founder and former guitarist for Taking Back Sunday.

"Embrace was a massive reason that we became a melodic band with singable melodies," explains Chris Conley, vocalist and guitarist of Saves The Day. "We loved Minor Threat. They sounded like Bad Brains, and they were just so raw and aggressive and powerful, and then [Ian MacKaye] starts Embrace and that record was so important. If anybody out there that's reading this has not heard that Embrace record, you have to go out and get it today. That was a massive reason why all the bands in that era sounded like they sounded. It was so much of Embrace. They were beautiful and sad and melodic and cool."

Fred Mascherino: "I really liked Fugazi. Their ethics were so up here. (Motions above his head.)"

"I learned how to write lyrics by listening to Fugazi," says Matt Pryor, vocalist and guitarist of The Get Up Kids. "They would always write really abstract lyrics about really specific things. I kind of took that approach."

It may seem counterintuitive that the vulnerability and melody for which emo became known actually stems partially from one of the biggest icons in hardcore, Ian MacKaye, cofounder of Dischord, as well as vocalist for Embrace, Fugazi, Minor Threat, and Teen Idles. But, upon closer examination, we can see the first breadcrumbs of emo in Minor Threat songs, even though he still, for the life of him, can't tell you what emo music is or why he's relevant to it. (**Chris Conley:** "Oh, give me a break. That's just silly.")

"People often say that Embrace or Rites of Spring were the first bands to really talk about their feelings." MacKaye reflects. "But if you listen to Minor Threat, there's a song called 'Look Back & Laugh,' where I not only talk about my feelings, I actually articulate them and enumerate them and give them voices. It was just interesting to me that somehow emotion was a new component to punk, since for me that was certainly not the case. It was always about emotion."

"I'm telling you I want it to work
I don't like being hurt
Something's not right inside
And I can't always put it aside
What can we do, what can we do?"

—Minor Threat, "Look Back & Laugh"

"I think there's a tendency to oversimplify," MacKaye continues. "Emo is interesting, because it's not a term I ever used with any seriousness. It was a derisive term making fun of Embrace and Rites of Spring. There was an ongoing joke in Washington, where there was hardcore, then metalcore, then deathcore, then rasta-core and krishna-core and jazz-core. At Dischord, we made up a fake chart of different -cores. Brian Baker—he was the bass player of Minor Threat and then he was in this band Dag Nasty—was the one I think (and I wish I could find it, I think it was in a *Thrasher Magazine*) said, 'Those guys are playing emocore and talking about their feelings.' And he was making fun of us as emotional hardcore. It was just ridiculous, we thought, because we were punks making punk music."

So to satisfy the question of "What is emo?" in one sense is to say that it is a subgenre of punk and hardcore. Or rather, it is the tagline associated with a particularly emotional brand of punk and hardcore that nobody wanted to be associated with in the first place. When the term "emo" first got thrown around, there was essentially already a built-in handbook for how to mock it.

"Rites of Spring was one of the greatest bands ever live," MacKaye asserts. MacKaye, who has meticulously catalogued all of his experiences in the DC punk and hardcore scenes of the 1980s, cites a previous journal entry: 'July 29th, 1984—Rites of Spring go on. Great show. Guy [Picciotto] snaps his guitar in half while he flips over the bass cabinet.' "

As for what other people thought about the band, MacKaye says, "There was a mythology around them

about everybody crying all the time, which was not really true."

But, if it's not true, then where do these jokes and mythologies come from? To have arisen at all, they have to have been based in *some* small grain of fact. While they may not have been sobbing into handkerchiefs on stage, Rites of Spring certainly did create a new sound that marked a turning point for punk and hardcore.

"I think Guy's vocals were so mind-blowing," MacKaye recalls. "Nobody, including the band, had ever heard Guy's voice. They just practiced in the basement with no PA. So when we recorded and Guy went in to record the vocals, he just laid it out so hard. And that first session, I think he was pretty upset. They worked so hard and then Mike Fellows (bass) had decided to leave, so it was loaded. Guy just threw down so hard, and that was really exciting to hear."

"Remainder" by Rites of Spring (excerpt)

We are all trapped in prisons of the mind,
It's a hard sensibility
But we'll see it through in time
But when words come between us
Noiseless in the air
Believe me, I know it's so easy to despair

But don't
Tonight I'm talking to myself
There's no one that I know as well
Thoughts collide without a sound
Frantic, fighting to be found

And I've found things in this life
That still are real
A remainder refusing to be concealed
And I've found the answer lies in a real emotion
Not the self-indulgence of a self-devotion

For the first time, there was a punk band whose lyrics were extremely poetic and introspective—more so than Minor Threat's songs. Rites of Spring offered the same kind of punk beats and sensibilities that virtually any other punk band offered, but they were the first to pair these things with more distinctive riffs and guitar melodies and deeply reflective, personal lyrics that rode on vocals that were sometimes very guttural and scream-oriented. Songs such as "Deeper Than Inside" and "Remainder" very obviously provided the next generation of punk and hardcore kids with the raw materials they would use to make what would later become known as emo.

"Deeper Than Inside" by Rites of Spring (excerpt)

I'm going down, going down, deeper than inside
The world is my fuse
And once inside gonna tear till there's nothing left
To find
And you wonder just how close close-up can be?

But while Rites of Spring made such an impact as to lead US Executive Director of *Kerrang!* Ethan Fixell to refer to them as "the holy grail of emo," the band, which had formed in 1984, did not have a lengthy career.

"Rites of Spring played maybe two or three shows outside of Washington," MacKaye says. "I think they did one show in New York and one show in Detroit with Sonic Youth. I think they played about seventeen shows, period. But I always tell people, 'There were only twelve people at the dinner with Jesus, right?' That seemed to get the word out...' "

REVOLUTION SUMMER #B

RITES OF SPRING

EMBRACE
GRAY MATTER
FOOD FOR THOUGHT

SUNDAY JULY 28
10:00 A.M.

1738 CONN. AVE. N.W.

$ 15.00 GEN ADM STANDING 15.00

6.25 WWW.STARLANDBALLROOM.COM
SECTION/AISLE
GA HAWTHORNE HEIGHTS

GA 5X *
ROW SEAT
GA+ 233 STARLAND BALLROOM

QKJ103 SAYREVILLE, NS

22NOV05 SAT DEC 3, 2005 6:44PM

PV0814 GA GA0 296 J-TYP
EVENT CODE SECTION/AISLE ROW/BOX SEAT ADMISSION
$ 30.25 GEN ADMISSION 30.2

7.25 SAMSUNG & CINGULAR PRES
SECTION/AISLE
GA VANS WARPED TOUR '05

CA 46X * * * *
ROW SEAT
GA0 29 OLD BRIDGE RACEWAY PARK

ORJ104 ENGLISHTOWN, NJ

12AUG05 SUN. AUG 14, 2005 DRS 11A

STANDING ONLY

BRAND NEW

EVENT CENTER
BORGATA CASINO, HOTEL AND SPA

An Emo by Any Other Name...

"Being called emo is a scarlet E across your guitar strap—a mark of shame or a reason to beg off and plead ignorance. Being an emo band is kinda like being in the KGB—everyone knows who they are, but no one admits anything and no one likes talking about it in public."

—Andy Greenwald, *Nothing Feels Good: Punk Rock, Teenagers, and Emo* (2003)

The word "emo" has quite nearly overshadowed the music it attempts to describe. Actually, many people would claim that it has. Depending on who you ask, the word "emo" is either an unwanted shackle or a suitable shoe. Half of the people who grew up playing in bands that generally fall under this category hate the word because it was something somebody outside of the scene came up with. For my part, when I was in middle school and high school, "emo" was definitely thrown around as more of an insult than the name of a genre. To be labeled "emo" was to be cast as an outsider. If you were dubbed emo, something was wrong with you. But at the same time, I liked the fact that I was emo. I thought the bands that I listened to, like Taking Back Sunday and The Used, were emo, and I loved them for that because they were painfully honest about pain. Babs Szabo, one of the cofounders of the now extremely popular club event Emo Nite, happens to feel similarly:

"I think even at the time when the term 'emo' was viewed somewhat negatively," she says, "it still didn't impact people wanting to be a part of the culture. When I was in high school, it definitely was not cool to be emo in school. But outside of it, when you went to see shows, that's when you were part of a community. That was the only time I felt like I was a part of something and not an outsider."

Ethan Fixell (*Kerrang!*): "There's nothing about true, legitimate emo that's worth making fun of. Some would argue that we have Jimmy Eat World to blame, as the success of their single 'The Middle' opened a path to mainstream success for pop punk bands, and the lines between genres became so blurred that emo

became a catch-all term for pop punk with whiny vocals and sensitive lyrics—music that's easy to ridicule as saccharine or cheesy. By 2004/2005, the term 'emo' would become a punchline. (For the record, the term seems to be gaining dignity over time, especially with the fourth wave of emo bands that now pay homage to first and second wave acts.)"

William Goldsmith (Sunny Day Real Estate): "The whole emo thing...so this is not meant to be in anyway insulting to anybody that is into that label, but in the punk rock scene, the first time I ever heard anybody use that word, it was a way of insulting someone. I had never heard that before, but it was very obvious it was an insult. I don't really know what happened, but I guess somebody in the industry had to come up with a way to sort of market it or put a label on it. At that time, there was grunge. Now here was this other thing, and they were like, 'Shit, what are we gonna call this?' When I found out that there was a new genre of music called emo and that we were one of the pioneers of it, I was like, 'WHAT?! Wait! That was the insult! It's not a genre of music!' So that was kind of hard to deal with."

Matt Pryor: "The term 'punk' was derogatory initially, too. It's an evolution of language, but it is very much a case of outsiders."

Shane Told (Silverstein): "The main [movement] I'd say I would compare [emo] to is the goth movement. Really, the emo thing was an extension of that, repackaged and repurposed. Now, 'goth' made sense because 'goth' stood for 'gothic,' which everyone thinks of as dark and black. But 'emo' is such an easy-to-make-fun-of word. 'Oh, you're emo.' So I think it was really easy for somebody who had

no association with it […] to poke fun at it. You could poke fun at it based on a guy like me, up there borderline crying on stage. Or, you could poke fun at some girl who has her hair fourteen different colors and piercings in her face."

Tom Mullen (*Washed Up Emo*): "After 150 plus interviews for my podcast, the tag 'emo' still has weight to this day and has survived while being the most hated word to describe a genre. [It] is pretty remarkable."

Chris Simpson (Mineral): "I don't love it, as terms go. To me, it doesn't feel useful in the sense that such a large amount of things have that term slapped on it; a lot of different sounding bands, to my ears. It seems to be more of an aesthetic than a sound. I don't know what it means, really."

Steve Lamos (American Football): "I don't know why people associate us with [emo]. I guess 'cause of Mike [Kinsella]. Nobody really cared about American Football when we existed the first time. I think there's been some interesting revision of history as people have picked up on that first record, and now they associate us with that music in a way that I certainly don't think they did at the time. I thought of The Promise Ring or Grade or Cap'n Jazz as that genre. But I have no idea why American Football is necessarily included in that, other than the Mike connection. But if that's the kind of music that attracts the weirdos and the people who feel like a square peg in a round hole, then I'm fine with it. Nobody really seems to want to claim this title for themselves, but maybe that's what emo means."

Ian MacKaye: "Thursday...are they an emo band? The Promise Ring? Jets to Brazil? So, anything that Blake [Schwarzenbach] was in...Huh. I don't want to dismiss emo. It's such an obscure form and so hard to define. I don't know what the criteria is to be emo."

Kenny Vasoli (The Starting Line): "If you sing about relationships and you have kind of a high voice, you might be in an emo band."

Eddie Reyes (Taking Back Sunday): "People always said that we were emo, and we never ever thought we were. To us, the real emo bands died out in the late '90s. For some strange reason, someone in some big magazine decided to attach that name to the music that came out of the punk rock scene. It was just instant—everyone's emo. My Chem never thought they were emo; they thought they were punk rock kids from Jersey. It's kind of like when you watch Dave Grohl talk about the Seattle punk scene and all of a sudden they were grunge, and they were like, 'What the fuck is grunge?' "

Chris Conley (Saves The Day): "It kind of depends on who you're asking. I think it's amazing, because I first heard the word 'emo' when it was about Sunny Day Real Estate and Embrace."

Ethan Fixell: "The first time I ever heard the word 'emo' was while recording an EP with my high school band at Mike Watts's Vu Du Studios in Long Island, New York. An engineer named Sean Hanney told me that our music shared a lot of similarities with a movement that was happening at the time: this 'emo' thing. He played me Saves The Day's *Through Being Cool*, and I was totally into it. Shortly after, I read a piece in a 1999 issue of *Guitar*

World by Jim DeRogatis that was titled, 'Emo (The Genre That Dare Not Speak Its Name).' "

"Emo (The Genre That Dare Not Speak Its Name)"
by Jim DeRogatis (*Guitar World*, 1999)

Once again there's a hard-rocking sound galvanizing the underground. You can call it post-hardcore. You can call it post-punk. You can take a step back and just call it indie-rock. Any name you choose is bound to prompt an argument with somebody, so you might as well bite the bullet and call it the name that *nobody* likes: Emo.

Tom Mullen: "The words 'emo' and 'emotion' are things I would see at early shows when screamo bands would pour out everything they had on the stage, and by the end they'd all be so tired and exhausted from the set. The entire time watching it would be this feeling of the show being on the brink of breaking, but it never does. That tension, that moment of feeling like the music can go anywhere [...] is what emotional means to me and what emo has always meant to me."

Chris Conley: "Anybody [who] says they don't like emo that was part of emo is just fronting. It's lame."

Eddie Reyes: "I feel like the people that hate it don't really hate it. I think that they are truly emo kids deep down inside that just think it's cool to hate it. I'm a fuckin' emo kid."

It would seem that the jury is out on whether "emo" is a good thing or a bad thing. An entire linguistics class could be dedicated to this subject for how much trouble this

little three-letter word has been causing. But, if you think about it, is it really that much of a surprise? Humans have maintained pretty poor relationships with their emotions for as long as they've had them. Every day we are puzzled, even baffled, by them. It's hard for many people to look their emotions square in the eyes. Many flat out ignore their emotions, even though what makes us human is our capacity to think and, most importantly, to feel. So the word "emo" is intrinsically problematic because emotions themselves are intrinsically problematic. Calling someone or something "emo" is to blatantly and singularly identify them or it as not just having emotion, but having a more emphasized relationship with emotion to the point where it needs to be commented on.

Nobody ever self-described as emo to begin with because the people who were making the music already *knew* they were doing it with extreme emotion—that was the point. But people who weren't making this music and people who weren't feeling the types of emotions that these bands were articulating were at odds with it. That's because it's difficult for people who haven't suffered to understand suffering, and suffering is a large part of what these songs and records were confronting. And what generally happens when people are confronted with something outside their comfort zone? There is resistance. There is degradation. There is othering. And that's all because, initially, there is fear.

To control that fear, people gave it a name: Emo. Once something has a name, it can be easily packaged into a neat little box and contained. But if there is one thing that none of these bands wanted to be, it was contained.

"This is not pretty," remarks Shane Told, vocalist of Silverstein. "[It's] in your face. I think that and the screaming that was coming into the music, too...this was not background music. This is intense music and if you're a fan of this, then you care about this and then it was like, are you all in or not? If I'm listening to this music, then I am *listening* to this music. That was when it became such a thing, when people's lives started revolving around these bands."

Jacob Marshall, the drummer of MAE surmises, "It wasn't trying to brag about your conquests or achieving a certain lifestyle status. It wasn't mindless, it was mindful. It was actually reflecting deeply on the things that hurt us or healed us."

Reflecting deeply (and out loud) about emotions like pain and love is not traditionally culturally acceptable for a male, and the bands in the emo and screamo music scenes were mostly comprised of young men. Sure, it was okay for the likes of William Shakespeare and Edgar Allan Poe to do, but in the twentieth and twenty-first centuries, the average man was not setting out to write a great sonnet. The prevailing mentality was that emotions were things that belonged to women.

Jacob Marshall: "In culture in general, there is a certain expectation of what masculine energy is supposed to be. When something shows vulnerability or invites the more reflective aspects of our nature and puts that front and center, that makes people who are, in a sense, trained to hide their emotions very uncomfortable. So it's easy to make [emo] a derogatory thing. *I've* never thought of it as a limitation."

Ryan Phillips (Story Of The Year): "Not to be derogatory, but it's not hard to imagine a super jock guy to be like, 'Man, this guy sounds like a pussy.' But then you've got another guy or girl that's more sensitive that's like, 'I've had my heart broken, and I feel like screaming to the world,' or, 'If my girlfriend cheated on me or broke my heart, I wish I could scream this right to her face.' And to some people that really struck a chord. It's okay to wear your heart on your sleeve. It's okay to be emotional. That doesn't make you weak. It doesn't make you less than."

Chris Simpson: "It didn't feel like weakness to us—it felt like our strength. Across the board in punk rock and indie music at the time, there was probably some feeling that that was kind of a weak thing to do. I think that's maybe why emo got such an easy and immediate backlash. But a lot of that had to do, I think, with the term. Critics and people on the outside put this little cutesy term on it that, to me, felt belittling to the content and the music. I listen to the power of some of the music, and there's something very masculine about the music but also something very soft and feminine. It can kind of hold both of those things. You could write about anything. I think that should always be the case with any sort of art or expression. I think there are times throughout history where it kind of becomes something that you don't do, that isn't done."

David McLaughlin (Associate Editor, _Kerrang!_ UK): "It's become a lot more commonplace to do so in recent times, but when I first got into emo, there weren't a lot of artists around who articulated their personal pain and embraced their own faults and failings like this genre seemed to. So I think starting that conversation in the alternative music sphere was emo's key purpose. You hear it said a lot now

that 'it's okay to not be okay,' but the first time I felt like that was true was through emo bands. When you consider how much more open the world is [now] about its issues with toxic masculinity, there's an amazing trickle-down effect from artists who dared to be emotionally vulnerable back then. Especially when compared to the braindead, Neanderthal attitudes celebrated across the mainstream metal world (which was then equally dominant in the pop charts)."

Plenty of men and young boys who didn't feel it was possible to talk about their feelings never got the help they needed because of such toxic masculinity. There was (and still is, albeit less so) a sweeping sense of shame and guilt to admitting to emotional suffering.

Jamie Tworkowski (To Write Love On Her Arms): "For us as a [mental health] organization thirteen years in, I know it's true that we hear from more females than males. When I show up to speak at a college, there's always more young women in the room than guys. I think what we see, and it's sort of stating the obvious, but it's sort of easier for women to talk about their feelings and to talk about their struggles. We get excited, and it's always felt important to make it known that the work we do is intended to be inclusive. The work we do is for men and women."

What emo music did that mainstream thought didn't approve of was throw traditional macho behavior out the window. The bands who started to develop this sound and this scene were tired of the straightforward aggression and masculine posturing of other rock, metal, and punk genres. Emo and screamo bands didn't want to fake a socially contrived sense of masculinity; they wanted to convey true emotions exactly as they were. At first,

creating an inclusive community with their music was mostly just a byproduct of their creativity, but as the scene gained a greater following, there developed a distinct intent to preach inclusivity.

Ethan Fixell: "As much as we all love Black Flag or Bad Brains, I think hardcore punk fans were desperately yearning for music that was less politically charged and generally raucous, and more personal, reflective, and viscerally painful."

Shane Told: "Punk music from before was like, 'Yeah well, you don't like me? Then fuck you.' Emo was like, 'You don't like me and I'm really sad about it and I'm just gonna listen to The Cure and think about this and what's gonna happen the next time I see you and how I'm gonna feel.' That's real. That's different."

Ryan Phillips: "The lyrics were a lot more vulnerable and a lot more sensitive and, I think, in the zeitgeist, it kind of caught on because people were craving that after listening to Limp Bizkit and Korn. Maybe I'm wrong on that, but that's how I felt. I was so into the nü metal stuff, but then [I heard] Jimmy Eat World and Finch and Glassjaw. I remember the first time I heard Glassjaw, and that was like the death of nü metal for me. It was a relief from the macho-ness."

Chris Conley: "After punk and grunge, everyone was still aggravated and alienated. Thank god emo came around because all of a sudden you were allowed to have your feelings. You were allowed to be who you are."

Aaron Gillespie (Underoath): "We wanted to feel angst like punk rock did but inject a little melody into it… We all went to the garage and were angry or hurt or happy or sad and we made these songs and people resonated with them. Our influences were Glassjaw and Thursday and bands that were doing something really, really vital and really fresh."

Emo music culture was brave enough to challenge the established idea of what it meant to be a man. It was brave enough and daring enough to admit that life wasn't all nice and peachy and to convey what that frustration, sadness, or insecurity felt like without pulling any punches. In *Everybody Hurts: An Essential Guide To Emo Culture*, Leslie Simon and Trevor Kelley write, "In the end, being emo is all about having the kind of unwavering conviction that allows one to face the challenges of a new day."

As time passes, far more people embrace the term "emo" and adopt it as their own, wearing their black eye like a badge of honor. (Ten points to you if you got the "There's No 'I' In Team" reference.) As we grow more distant in time from its inception, "emo" increasingly becomes a legitimate descriptor for a crucial moment in rock history, rather than a slight to those who dare to interact with their feelings.

"I think one thing that's been really true for our scene several times over," says Chris Carrabba of Dashboard Confessional, "was that there was a lot of overlapping of different genres that were unified by the nakedness of the emotionality that the singer was willing to display. I listened to this music because it was so emotional. They're singing songs about what it is to feel. It's not love songs. It's not heartbreak songs. It's just about what it *is* to feel."

To me, *that's* what it means to be emo: being willing to feel the painful emotions as profoundly as the pleasant ones. It makes me proud to be emo, because, to me, the word symbolizes emotional strength. But, in the end, I really don't get as hung up on the word as many of the bands that are described that way seem to. People could have used it as an insult, and they did, but those people's definition of emo wasn't the right one. To me, "emo" was the name that was used to describe the bands and the music I loved: the songs that saved my life. And that's all it is—a name. I don't care what it's called. It could be any name in the world, and I would still look at it the same way. (And if I recall correctly, Shakespeare said something similar in a little play you may have heard of, Romeo & Juliet.) So enough of mincing words. Let's talk about the goddamn music.

$ 15.00 GEN ADM STANDING 15.00

6.25 WWW.STARLANDBALLROOM.COM
SECTION/AISLE
GA HAWTHORNE HEIGHTS

GA 5X
ROW SEAT
GA4 233 STARLAND BALLROOM

OKJ103A SAYREVILLE, NJ

22NOV05 SAT DEC 3, 2005 6:30PM

PY0814 GA GA0 296 J-TYP
EVENT CODE SECTION/AISLE ROW/BOX SEAT ADMISSION
$ 30.25 GEN ADMISSION 30.2

7.25 SAMSUNG & CINGULAR PRES
SECTION/AISLE
GA VANS WARPED TOUR '05

CA 46X * * * *
ROW SEAT
GA0 296 OLD BRIDGE RACEWAY PARK

ORJ104 ENGLISHTOWN, NJ

12AUG05 SUN AUG 14, 2005 DRS 11A

STANDING ONLY

BRAND NEW

EVENT CENTER
BORGATA CASINO, HOTEL AND SPA

The Anthem of Your Underground: A Look at '90s Emo

One of the most significant events in all of human
history took place in 1991 when the World Wide Web
became public. In 1992, the LA riots tore the California
city apart. "The Macarena" craze sparked in 1993, Kurt
Cobain committed suicide in 1994 (whether it was because
of "The Macarena" remains to be seen), O.J. Simpson beat
his murder charges in 1995, and Coolio released "Gangsta's
Paradise" that same year. The Spice Girls changed the
world seemingly overnight with their hit song "Wannabe"
in 1996. NASA's Mars Pathfinder successfully landed on
the red planet in 1997. In 1998, Monica Lewinsky and
President Bill Clinton had an affair that would end up
becoming the punchline of roughly 50 percent of all
Eminem lyrics. And finally, in 1999, while the world
was plunging into Y2K madness, virtually every notable
boy band or female pop star came out with their biggest
releases, from The Backstreet Boys's "I Want It That
Way" to Christina Aguilera's "Genie in a Bottle" to TLC's
timeless "No Scrubs." This was the historical background
from which emo emerged: a pop culture explosion.

In the era of what most people claim to be the best of hip-
hop and bubblegum pop, punk dove deep underground. It
wasn't front and center like it was in the 1970s. It wasn't
on the streets like hardcore was in the 1980s. Now, punk
was in the basement, and that's where it would begin
to morph into something new. With the passing of Kurt
Cobain came the end of grunge and the beginning of what
would become known as emo—not that anyone knew it
at the time. Sunny Day Real Estate, who also happened to
be based in Nirvana's home city of Seattle, were about to
come on to the scene and change everything.

Ethan Fixell: "Some would argue Sunny Day were more alt-rock than emo, but they directly influenced more emo-related bands than any other artist on this list. While Mineral played it sad, and The Get Up Kids played it fast and snotty, Sunny Day were brooding and detached."

Chris Simpson: "I think Sunny Day Real Estate and their first record, *Diary*, was the first kind of catalyst. Everyone knew Sunny Day Real Estate. There was a depth to them that I feel like a lot of punk rock that I had heard didn't have."

William Goldsmith: "All ages shows were illegal here in Seattle. It was tricky because Jeremy was eighteen, and I was just about to turn twenty-one. So we weren't even old enough to play in bars yet. We were creating music that was specifically for us—it wasn't for anyone else to hear. We didn't think anyone was gonna be able to hear it, so we were making music for the sake of making music— because we wanted to. We didn't expect to get out of the basement. There were no plans to play any shows. So it was deeply personal. When we started playing shows, it felt strange. It felt like somebody watching you go to the bathroom or something. Something that's normally a very private thing. So that was kind of odd."

The quality of the music they were making was higher than what one would usually find in a bathroom, however—much higher. With a touch of luck, their basement would soon turn itself inside out and put Sunny Day Real Estate in the spotlight.

William Goldsmith: "Somehow Kurtis Pitz was able to put on an all-ages show. Then there was this other band, Engine Kid, that was supposed to play with this band

called Skirt at The Crocodile Cafe in Seattle. Engine Kid actually ended up not being able to play the show, so they told the booking agent they recommended they put us on the bill in place of them. So the booking agent put us on the show and we played and then he said, 'Hey guys, I'm gonna put you as the very first band at the Sub Pop anniversary party show here at The Crocodile. I just wanna see what happens.' We were like, 'OK, whatever.' So we played the show, and there was only one person in the room that was watching us play. I think it's probably because Eric Soderstrom, the booking agent, went up to Jonathan [Poneman] and [told him] to watch this first band. We got done playing, and he just walked up to the stage—it was literally an empty room—and he said, 'Hey, do you guys wanna make a record?' We started laughing. We were like, 'Yeah, right. What are you joking?' And he was like, 'No, because I'm Jonathan. I'm president of Sub Pop Records.' Sunny Day Real Estate was able to make a record literally by accident. Ultimately, it was a total fluke."

That "total fluke" would end up making some serious waves in rock history. When Sunny Day came out with *Diary*, it brought countless other bands out of their basements and into…well, other people's basements (at first, at least).

Dan Marsala: "Sunny Day Real Estate and The Promise Ring, that was emo to us."

David McLaughlin: "Everyone screams and shouts about how great *Diary* was (and it is), but [*How It Feels to Be Something On*] is so connected to my first serious relationship, the inevitable breakup, and how it helped me

pick up the pieces again. A girl broke my heart, and this record helped me heal it—what an emo cliché!"

Chris Carrabba: "Sunny Day Real Estate had come before me. In zines and stuff, they had been called emo, so that's what we thought they were. I was like, you know, obviously I'm not like Sunny Day Real Estate. Nobody's that good."

William Goldsmith: "You could say that to me, but it's hard for me to wrap my head around. It's really cool to have inspired anybody at all. We wouldn't have existed without the same thing. We can point back to Fugazi. We can point back to Rites of Spring. All these different bands, they're the reason our band existed. Our band was essentially an experiment. People had been playing hardcore for quite a few years. We come from music that isn't good, but wasn't necessarily meant to be good. It was a statement: a place to start. It was an experiment with guys who had been playing hardcore, trying to write songs and learn how to use music as a form of more sophisticated storytelling. This took me years and years to try to get a handle on and actually learn how to leave space for melodies. When Jeremy joined the band, that really enhanced that experiment. We had to focus even more because we finally had someone who could sing. Jeremy had also been playing hardcore, but […] he started when he was a little kid and sat in his room with a four-track and wrote songs like 'In Circles.' That was natural for him."

"In Circles"

Meet me there
In the blue
Where words are not
Feeling remains
Sincerity
Trust in me
Throw myself into your door

In circles (I'm running down)
In circles (running down)
In circles (running down)

"In Circles" is a prime example of how Sunny Day Real Estate connected the dots from grunge to the next subset of punk music: emo. The verses of "In Circles" are the dictionary definition of what emo sounds like, but the angst-ridden choruses sound distinctly influenced by Nirvana. The vocals change from drawn out and sad to forceful, strained, and kind of mumbled à la Kurt Cobain. So, at the same time that emo was a natural progression of punk and hardcore, it was also the next stage of evolution for grunge. In a strange, albeit unfortunate cosmic way, the actual timeline works out eerily well: Kurt Cobain died in 1994, and, just one month later, Sunny Day came out with their acclaimed debut record, *Diary*. The tie becomes even stronger when you consider that the two bands were signed to the same label, Sub Pop. (Another "total fluke" perhaps.) While William Goldsmith never officially met Cobain, his death shocked him just as much as it did everyone else.

"A few months before he died," Goldsmith says, "Jawbreaker had toured with Nirvana, and they gave us their all access passes. So we were able to basically go backstage [...] and watch [Nirvana] from side stage. Man, their tour manager was so pissed because we had the passes that were needed to be there, but he knew we weren't supposed to be there. Then, the next thing you know, shit happened. When Kurt died, that really kind of fucked with my head. I didn't listen to Nirvana at all from the day that I found out that he died. I only listened to Nirvana for the first time again about a year ago."

Opinions may differ on whether or not that particular event marked the end of grunge, but that's how pop culture and history will remember it. The death of Cobain, the talented, sulking rock star of the time, drew a line in the sand. The only question left was, what's next?

Sunny Day Real Estate had no idea that they were going to be part of the answer to that question. "I just wasn't aware of any of this stuff," Goldsmith says. "I just didn't know. It was years later [that I found out I was influencing bands]. I probably didn't really become aware of that until the early 2000s."

As it was with Rites of Spring, Sunny Day's initial run was pretty limited. The band essentially broke up right after they started. They had more fans postmortem than they did when they were out playing shows.

William Goldsmith: "There was no one there. Nobody came to the shows. We went on tour with The Dirt Fishermen, and we played on average to about seven to ten people a night. Following that was a tour we did with Thirty Ought Six, and there was anywhere from two to

six people there on average. Then I think we went on tour opening for Velocity Girl after that, and they had some people that came to their shows. So that was the first time we were playing some shows where people were actually showing up. But that wasn't because of us; that was because of people who were into Velocity Girl. Then this idea came of us going on tour with Shudder To Think, along with Braniac for the first half and Soul Coughing for the second half. What was weird is, right before we went on that tour, we broke up. When we were on that tour, we were no longer a band. It was toward the end of that tour that all of a sudden we started to see the shows start to get a little bit bigger. I remember it was in Portland and we got done playing and the reaction that people had…they were clapping and they were kind of stomping for us to come back out. That was the first time I really realized that we were actually having a kind of spiritual interaction with the people that were there. I remember I broke down crying because I had never experienced that. I just couldn't believe it. We were the opening band. You're not supposed to do an encore. It was so unexpected. They genuinely wanted us to keep playing."

But keep playing, they would not. Still, the music they released during the band's short run in the '90s would echo loudly and incessantly in the years to come. But they weren't the only ones who made a big impact. While Sunny Day made up a significant chunk of '90s emo, bands like Jawbreaker, Jawbox, Jets To Brazil, Cap'n Jazz, Joan of Arc, Lifetime, Braid, Jimmy Eat World, Grade, The Promise Ring, The Get Up Kids, Saves The Day, and Mineral were also key emo outfits and/or influencers.

Tom Mullen: "The genre itself was right alongside hardcore, punk, indie as a genre that was part of a bigger community. A band like Christie Front Drive or Braid or Rainer Maria are connectors, trailblazers for so many of those that came after them from this scene. Hearing The Get Up Kids or Sunny Day Real Estate for the first time, learning about their history, then going back to learn what came before and what inspired them is something I'll never forget. That is still happening today."

Ethan Fixell: "What instantly hooked me were bands like Jimmy Eat World, The Promise Ring, Jejune, and The Get Up Kids, which all managed to brilliantly smooth out the raw intensity of punk rock with beautiful melodies and introspective lyrics. It blew me away and was easily the most influential musical moment of my life."

Shane Told: "I would listen to The Get Up Kids, one of my favorite bands, and I'd play it for people, and they'd be like, 'He can't sing.' The Promise Ring, especially. I didn't care or I didn't notice that it was off key."

Kenny Vasoli: "I was fourteen when I met Matt Watts and we formed The Starting Line together. He didn't really know I was fourteen, and I didn't really tell him because he was twenty years old, and I wanted to play with people like that who were more advanced. He was exposing me to bands like The Get Up Kids and Jimmy Eat World. I also had friends who were into Fugazi and The Promise Ring and J Church and Jawbreaker and things of that nature. I was getting a nice, well-rounded education of what the subculture of punk was at the time. Emo was sort of the slang for what At The Drive-In and The Promise Ring and J-Tree bands were doing at the time."

Chris Conley: "If you look at how many incredible songwriters were in this field of music, it's astonishing. I instantly think of Matt Pryor of The Get Up Kids. I still feel starstruck when I'm around them. Their incredible gift of songwriting and their incredible professionalism was a massive influence on me, and I would say every single other emo band."

While none of these musicians can seem to agree on what defines emo, every one of them agree when it comes to identifying the big players in the budding genre. Next to The Promise Ring and The Get Up Kids was Jimmy Eat World, whose album *Clarity* basically became the emo bible. Ironically, it was also the album that got them dropped from Capitol Records because the label thought it would be a total flop.

David McLaughlin: "When Jimmy Eat World broke through, that's when the UK really became aware of what emo was, as far as I could tell. Or at least that wave of bands who would be classified as emo. There were a lot of amazingly sweaty and soul-stirring shows in those days."

Fred Mascherino: "That first album [*Static Prevails*] by Jimmy Eat World was the continuation of Sunny Day Real Estate. When that came out, the review in *Rolling Stone* said, 'Fans of Sunny Day Real Estate have a new band that they can listen to that might just take the place of Sunny Day.' And that was the only reason we checked 'em out."

But *Clarity* didn't have the same punchy guitars that their previous record, *Static Prevails* had. It was much, much calmer and more meditative. Most of the songs were slow and pensive, with minimal instrumentation and twinkling sound effects. *Clarity* is unlike any emo record that has

ever been written to the point where, when compared to all the other albums known as emo, it is probably more appropriate to call it soft rock. There was nothing like it before and nothing like it since. Yet, despite being an anomaly, this record remains at the heart of emo music.

Jimmy Eat World's next record, *Bleed American*, would be their gateway to the mainstream, though it was still true to the sound and the scene they came from. Since then, the band has continued to put out record after record and play tour after tour, all without losing their artistic *Integrity*.[1] (Get it?)

Chris Simpson: "I'd say maybe half of the shows we did were house shows or warehouse shows or some kind of DIY setup. Not traditional rock clubs. One of the later tours we did, when we toured with Jimmy Eat World and Sense Field, was probably one of the first tours that we played predominantly rock clubs. Although, in Atlanta we played in someone's basement on that tour."

David McLaughlin: "For me, it felt like [emo became mainstream] when Jimmy Eat World had an MTV/chart hit with "The Middle." That landed them on *NME* and *Kerrang!* covers, and when I saw them play live around that period of time, the crowds felt like they were special—like the celebration of a moment in time that had been building in an oddly nebulous way previously. As I saw it, that led to the much more saccharine (but admittedly still important to many) sounds of Dashboard Confessional."

1 If you don't get it, get it faster* and go to the record store and pick up *Integrity Blues*.
 *That's another Jimmy reference—just can't help myself.

Ethan Fixell: "They are the most commercially successful *authentic* emo band of all time."

But it wasn't only emo music that was influencing emo music. In the Northeast especially, the biggest influence on the emo scene was actually hardcore.

Chris Conley: "It was an amazing scene, first of all. There were shows every single weekend at VFW halls and the Princeton Arts Council and basement shows. All of the bands were good. It felt like every single band was special and cool, and there was a real community. We were just kids. The only other original member of Saves The Day, Brian Newman, and I were in high school, and on the weekends we would go to these straightedge hardcore shows. We would see bands like Mouthpiece and Lifetime and Endeavor. We were just so excited."

Chris Carrabba: "Lifetime was this amazing thing because I thought Ari was a visionary. When Lifetime came out with their first couple records, they were just a really fast hardcore band. There wasn't a lot of melody. They were just super fast, super tight, super concise, and he was this fierce singer. But then he started writing lyrics—maybe he always did, but once the melody was added to it, it matched the emotional content—for very emotionally driven songs. His sense of melody was so powerful."

The moment Lifetime and bands of their class began to change their sound from pure hardcore to melodic was the spark that ignited the fire for emo and screamo. There was now this hybrid sound that firmly began to take root and shape. It became less of an ambiguous idea or experiment and became something more substantial: a movement that was about to pick up.

Dan Marsala: "It was all this crazy blur. We were young and touring constantly. For me, that whole scene kind of started with 1990s punk rock and hardcore stuff. There were bands like Boysetsfire and Grade and a couple other bands that were doing the screaming and the singing at the same time. I was like, 'Man, you can get away with doing all of this?' It was all very divided until a couple of bands started doing it all together. I don't know; we didn't really think about it too much. 'Let's be heavy and sing.' It was simple. It was not really a thing yet. Didn't really think that it was gonna start a whole new type of music, which is still evolving and gets heavier and crazier and poppier."

Garrett Zablocki (Senses Fail): "At the heart of it, there were still pop sensibilities in the hooks. But it wasn't the traditional, polished sound. It was to a certain extent, which is why radio stations and MTV would play it. We turned to the stuff that was before us—hardcore, punk— and were like, 'OK, what's the next *fuck you*'?"

Chris Conley: "There was never an idea that [Saves The Day] would be a band in that scene and get to play shows with these amazing bands, but as soon as we made our first demo in 1997, literally that day, the bass player of Mouthpiece came to the studio and he said, 'You know what, this is really good. You guys could play hardcore shows.' We were like, 'Are you serious?' Because we were a pop punk band, basically, before that. We sounded like Green Day or Rancid—those were our main influences. Then we started getting into Gorilla Biscuits and Lifetime and we were playing the fast beat. All of a sudden, it went from being mid-tempo punk rock to aggressive, fast, melodic hardcore. Overnight, we got asked to play these

shows and [were] put on flyers, and we were part of that world. It was junior year of high school. We made the demo on April 17, 1997. We changed our name to Saves The Day that day, because our friend Sean McGrath, who was the bass player of Mouthpiece, he was the one that said, 'You guys could totally play hardcore shows, but your name is weird.' Our name at that time was Sefler, which was just a typo from computer class. It was just sort of a cool, weird-sounding name for us. Sean said, 'You know, I always thought Saves The Day would be a cool name for a band.' Basically, that's how it started."

Kenny Vasoli: "Our second show ever was with Saves The Day in a barn in Hershey, Pennsylvania, and we were geeking out so hard when *Through Being Cool* came out."

Dan Marsala: "That was the first time I heard a poppier emo band also play punk rock. If I think about emo and screamo, I think about Saves The Day. The lyrics were so dark and just different than anything else that was being said in a poppy manner at that point. It was so real and the music was really cool, too. But it was all about the lyrics."

As Dan says, emo and screamo would not have had the same impact had their lyrics been different. A band could play however many minor chords they wanted, but they wouldn't be part of this beautiful turmoil that is emo without the sad, sometimes sadomasochistic lyrics and the (mostly) poor vocals that delivered them.

Despite being an icon for the genre (or, probably more accurately, because of it), most people would say Chris Conley can't really sing. The same could be said of Buddy Neilsen, Geoff Rickley, Jeremy Enigk, Chris Simpson,

and virtually every other vocalist at the time. But that's
what made the lyrics weigh even heavier and gave them
more force. These teenagers weren't singing or screaming
because they thought they were qualified or that they
sounded good, they were singing and screaming because
they simply *had* to. The words begged to be articulated
with the same raw, off-putting emotions that they
conveyed on paper. It was like a one-two punch straight to
the heart from Mike Tyson if Mike Tyson was a scrawny
eighteen-year-old boy who had just gotten dumped for
the first time and then proceeded to wear a carabiner on
every pair of jeans he owned.

$ 15.00 GEN ADM STANDING 15.00

6.25 WWW.STARLANDBALLROOM.COM

SECTION/AISLE

GA HAWTHORNE HEIGHTS

GA 5X

ROW SEAT

GA4 233 STARLAND BALLROOM

OKJ103A SAYREVILLE, N3

22NOV05 SAT DEC 3, 2005 6:30PM

PY0814 GA GA0 296 J-TVP

EVENT CODE	SECTION/AISLE	ROW/BOX	SEAT	ADMISSION

$ 30.25 GEN ADMISSION 30.2

7.25 SAMSUNG & CINGULAR PRES

SECTION/AISLE

GA VANS WARPED TOUR '05

CA 46X * * * *

ROW SEAT

GA0 29C OLD BRIDGE RACEWAY PARK

ORJ104 ENGLISHTOWN, NJ

12AUG05 SUN AUG 14, 2005 DRS 11A

STANDING ONLY

BRAND NEW

EVENT CENTER

BORGATA CASINO, HOTEL AND SPA

CHAPTER 4

With Just a Pen, a Pill, and Some Paper

Lyrics can stand on their own, but it is up to the rest of us to figure out just why they are so important (aside from their inherent significance to the lyricist). Thematically, "emo" topics range from breakups to childhood abandonment to being in love. But, as Chris Carrabba points out, the songs aren't just *about* those things, they're about the way the lyricist *felt* about those things. The event that takes place in a particular song is merely the occasion for the artist to show up and to feel and to perform. The songwriters in emo and screamo bands had and still have an astounding talent for being able to anchor the listener in their voices and their lyrics, pulling them in to experience those things alongside them. No. I take that back. That's not right. Fans of this genre don't experience the lyrics alongside the bands, they experience the lyrics as though they *are* one another, occupying the same body, the same mind, the same breath. And musicians in emo bands felt the same way about the music that other emo bands were creating too.

Chris Conley: "I would just sit there and read the lyrics over and over and over again and just cry my eyes out. Thank god for that music. Thank god for it. Crying, writing lyrics, just trying to get through the day and the night. If I had never had that outlet, the pen and the paper and the ability to speak my mind, it would have all been stifled inside me, and it would've bottled up and exploded."

"Call It Karma"
by Silverstein

Blame it on the weather, but I'm a mess
And this February darkness has me hating everyone
And I know I need your comfort, but this drama
Makes me sick
And the longer I lay here I know it's harder to get up
Without you

Matt Pryor: "I think that it is punk music or pop music or indie music that has personal lyrics that people can relate to that aren't just about typical rock 'n' roll bullshit."

Garrett Zablocki: "This is where you have to give it up to the lyricists, like Buddy. We weren't talking about 'fuck the government' and all this bullshit. It was more introspective and talking about relationships and mental health. The chords and the music behind the vocals and lyrics definitely set a perfect stage to deliver that message."

Shane Told: "Lyrically, I was writing things that were so close to my chest. I was writing things that were so real that it was easy for people to relate to it. I wasn't trying to be overly poetic and vague. I was trying to be like, 'OK, I'm talking about suicide here. I'm talking about not liking myself or how heartbroken I feel. I'm talking about physical pain that I'm feeling from emotional pain.' That was something that people would be like, 'This is the first music I'm ever hearing in my life where he is singing something to me directly.' "

Chris Conley: "The world back then was awful to live in. It's still a friggin' nightmare. Back then, it was worse.

You weren't allowed to feel what you feel. How crazy is that? The experience was really tough and really sad and really painful. When you go back and listen to grunge, you sense this alienation but everybody's singing sort of gibberish. But, if you listen through the lyrics, if you listen to what Kurt Cobain is feeling, I mean the guy is crying. So [with] emo, you had poetic license to talk about your feelings. And I really believe Blake Schwartzenbach, the singer-songwriter of Jawbreaker, had a major influence on everyone."

Shane Told: "[The lyrics are] talking about the emotional pain and [how] I don't know what's going on in my own head, and that is something that is timeless. It's just how people are. So now, when you look back at this music and you think about what's going on now with this music and people are going out in droves to Emo Nite LA and Emo Night Brooklyn, and they're happening in pretty much every city, every weekend now. Those people are singing those words at the top of their lungs, songs that came out fifteen, twenty years ago because those lyrics still hold up today. It aged well and it's meaningful. I never held back."

Like every other emo kid, I would be listening to this music and these lyrics every chance I got: doing my makeup in the morning, during the two minutes I had in the hall to get from one class to another, and as a lullaby when I went to sleep every night, feeling like no one else was there for me. I clung to each and every word like they were life rafts thrown to me in the open sea.

But being alone with your headphones and listening to a band on record is a very different experience than seeing the same music played at a live show. At a live show, every movement, every emotion, every feeling is amplified

just as much as the sound is. The air, like your clothes, is damp with the smell of sweat. Unlike being in your room alone with your iPod, at a show you are surrounded by people who also vibe with this music and who, likely, also feel a similar pain. There is a kind of larger ego that develops (not in the jerk way, but in the Freudian way). The individual identity merges with a collective one. Your emotions are simultaneously within you and without you. It is love. It is desperation. It is relief. And the musicians responsible for getting you through the night when you'd rather give up are right there in front of you, feeling it too. Then, out of all the tension and all the pain, comes a euphoria unlike any other. At that moment, it is as Tom Mullen says: "Emotion in euphoria, and never sad, always smiling."

"If you feel like dying you might want to sing."

—The Used, "Let It Bleed"

Life in the Basement

"Look in the basement of your heart
There is a light that just went dark
Look through the wreckage to find reverie
There is a truth that we all must see"

—Senses Fail, "The Path"[2]

2 "The Path" is a hardcore song from Senses Fail's 2013 album, *Renacer*.
 "Renacer" is a Spanish verb which translates to English as "to be reborn."

We've heard the word a lot already, and hopefully you've been paying well enough attention to notice that this word just so happens to be on the front cover of the book you're reading right now. The word is basement.

It's the cold, dark, creepy, cramped, neglected room in your house. It's the deepest part of the home, often used to symbolize the deepest part of human consciousness. The gateway to the basement, the cellar door, has been noted to be one of the greatest, most beautiful-sounding phrases[3] in the English language by scores of authors and poets, including the master linguist J.R.R. Tolkien himself. There is no place, both physically and symbolically, more suited to being the birthplace of emo than this.

Most people consider the garage to be the symbol of rock music creation. In fact, garage rock is even a genre (or at least slang for a genre). But for emo, it was all about the basement. Band practice was in the basement. Shows were in the basement. This genre was literally and figuratively underground, and it still prides itself on that fact. Every musician from this scene references this place when discussing where emo came from, what it means, and what it represents in their memories.

Matt Pryor: "I guess it's special because you're getting rid of the gatekeepers. You don't have to have anybody's permission. Sometimes it was hard to get into clubs when we didn't have any [sense of] establishment because we were young. I think there's something that's really special about you and your friends, and people that you didn't know were your friends until you met them at that show because you had a common interest."

3 If you haven't already, watch the cult classic, *Donnie Darko* (2001), which explores the meaning of the phrase "cellar door," and which also happens to be closely associated with the emo aesthetic.

Ian MacKaye: "I think the basement is the venue of the art of necessity. People didn't practice in the basement because [they didn't] want to go to a practice space. They didn't have a choice. So, on one level, it's just the fact that when somebody has a mission, he or she will make do with whatever they've got. So the basement is a place where you can make music. But if you are waiting for a particular backline or rehearsal space, you're probably not ever gonna get around to doing it. But if you *have* to do it, you just go to the basement.

"Another thing about the basement—specifically the Dischord basement—is that it's very small. It's like forty square feet. The ceiling is about five feet nine or ten inches high. I can just barely stand up in there. Actually, I can't stand up in there. I have to put my head in the rafters, so it's about five-and-a-half feet tall. I think the intimacy of that setting allowed for us to do a lot of talking. You can engage with arrangements and precision. If you're in a room that's really boomy and echoey, it's hard to focus on the corners of songs. But if you're in a really small room and you can talk at a regular volume, maybe there's something to that. There was also no money in punk, so no one's renting a space to practice. Also, a lot of kids *were kids*, so they didn't have any money at all. Garages were kind of useless because they're not soundproof."

Fred Mascherino: "I go out and play and people look at me as a performer, but I still look at myself as a guy that loves music, that loves listening to music. When I was in Breaking Pangaea, we hated playing on stages. Our drummer would often set up on the floor at a club. It was always about...we're *you* guys. That's how Taking

Back Sunday felt as well. At the point when there's four thousand people coming to see you, you kind of need to be elevated in order to be seen, but we would've played on the floor if we could."

This love for the lack of boundary between fan and artist stems from hardcore ethos and is still representative of the hardcore genre and community today. It's the idea that a live show is not just the playing of a record. The live show is an experience: a feeling shared between band and audience to the point where there is no separation of the two. Because emo originally came out of hardcore and punk—came out of basements—it retains that ethos. No one from any of these genres considers themselves a rock star. Rock stars don't exist here.

Chris Carrabba: "The two biggest bands that came out of that scene would probably be Fall Out Boy and My Chemical Romance. Those kids came up from basement shows. I think they happened to get famous because they were incredible. I think they'd still be playing basement shows if they had happened to not get famous. I think they legitimately just loved and needed to play music."

Kenny Vasoli: "The bands that are playing those basement shows seem to have a lot more personality and a lot more character to their band."

Ian MacKaye: "With Fugazi, when we were not touring, it would not be unusual for us to practice five days a week, for four or five hours a day. We would just sit in the basement and talk for an hour and a half and just play a song. People [ask if I] miss playing shows. Sure, I miss touring, but what I really miss is the quality of time when you're just in the creative process with people. I think

great ideas don't happen in front of thousands of people. I think great ideas are hatched in front of a handful of people. That's why house shows and basement shows are [important]. If you wanna see something get born, hang out there. By the time it's in front of a thousand people, it's already grown up. It's an interesting phenomenon. People say we need more venues, but, actually, we just need places for bands to play, not venues. New ideas don't have audiences."

The basement is authenticity. The basement is authenticity because it is there when no one is looking. That's where the emotions found in these songs came from. They came from the dark. They came from the desperate. They came from the deepest part of the heart and the soul. When they were first being written, these songs came from the solitary or the few. When they were first being performed, they were in the small pockets of air found in between the dozens of locals who came to see their friend's band play. In both cases, the basement was a place of intimacy. At first, it was a secret. Then, it was a secret that everybody knew. Some would say that when these bands and their music left the basement, that's when they stopped being authentic. But the real emo music, the good emo music, always feels as though it remains there, no matter how many stages it graces and no matter how many records have been sold. The basement is a place that was always and will always be there for the creatives that need it.

Matt Pryor: "I don't really go to basement shows anymore, but I had to go to one last year because my daughter's band was playing

and she only had her learner's permit, so I had to be the legal driver in the car. So we went to this basement show in Kansas City, and I felt horribly awkward because I'm forty-two. I'm old enough to be everybody's dad. But it was the same sort of feeling for those kids that I had when I was twenty-one or younger and going to shows. This basement was disgusting, this PA was terrible, everyone smelled bad, but it was theirs. There's something really important about having that ownership. It makes me happy that that scene that was so meaningful to me when I was that age still exists. It didn't get ruined by the corporatization of the genre. It still exists in basements. That warms my heart more than anything."

A Decade Under the Influence: The Turn of the Millennium and the Early 2000s

The turn of the century was musically significant
for reasons other than The Backstreet Boys's *Millennium*
record. This was when emo bands were emerging from
basements and DIY venues and making their way into
festivals and stadiums (not that they had ever planned
for it). The 2000s would mark a point of no return for
the genre. But before bands like The Used, Story Of The
Year, and Underoath careened into the limelight, bands
like Taking Back Sunday and Brand New would stick the
proverbial flag in Long Island concrete.

Eddie Reyes: "I was in a bunch of other bands that were
staples of the Long Island hardcore/emo scene. I started
a band called Inside. Then I started a band called The
Movielife. I was kind of fed up with music and I just
wanted to do a record label, but a friend of mine, in a
coffee shop in Islip back in '98, told me that I shouldn't
stop playing. There, on the spot, I started the idea for
Taking Back Sunday."

Whoever that friend was had a keen sense for success, and
I'd like to personally thank them for their contributions
to my life and millions of other lives across the globe.
Because whether you're a fan of them or not, Taking Back
Sunday were undeniably one of if not the best emo band
arriving on the scene at the end of the '90s/beginning of
the 2000s. But first, they had to scoop up the guy who
would become one of the most iconic vocalists of the
scene: Adam Lazzara.

Eddie Reyes: "We went down to North Carolina to play
some shows, and a buddy of mine introduced me to
Adam. We met at a Waffle House and I said it was a cool
idea if he moved up to New York and slept on my couch

and tried out for the band. He just packed his bags, threw 'em in his friend's truck, drove up to New York, and slept on my couch. At one point, Jesse Lacey played bass for us; you know, so many people were coming in and out. Then around 1999 or 2000, the band was kind of settled in with Mark [O'Connell] on drums. Adam originally moved up to New York to play bass, but he was a far better singer than bassist, so I made him the singer. That's when Shaun [Cooper] got into the band and that was the lineup for *Tell All Your Friends*."

Tell All Your Friends. There are no words that I could string together that would ever be able to capture what this record means to me or the countless other first generation TBS fans. In my opinion, both as a fan and a music journalist, *Tell All Your Friends* is the quintessential emo record. If I were to try to explain to the uninitiated what emo is and what emo means, I would simply hand them a copy of *TAYF*. It's melancholy. It's hurt. It's unapologetic. It's beautifully raw and unrefined. It's angry in only the way that teenage poetry[4] can be. It's both over the top and minimalistic. It's Long Island attitude. It's the purging of all emotion until the throat is burning, like the feeling of whiskey as it comes back up the esophagus of a young hopeless, broken down in bars and bathrooms.[5] *Tell All Your Friends* is at once an album name and a direction. Go ahead. Tell everyone. They need to hear this, because this is the sound of a generation.

Aaron Gillespie: "Bands like [Taking Back Sunday] were an anomaly. It was something completely new and completely out of left field and completely theirs.

4 "Timberwolves At New Jersey"
5 "There's No 'I' in Team"

You'd never heard stuff like it before. It felt really special because no one knows what this is. This is ours."

Of course, Taking Back Sunday were not alone in playing a central role in the development of emo and screamo. In just the Long Island scene, there were other would-be emo legends dominating the developing genre. And, as it would happen, the other band that would become equally huge and influential was Brand New, the outfit fronted by former friend Jesse Lacey. In the years to come, these two bands would be forever intertwined in a story of love, betrayal, hatred, and sorrow.

> "Is that what you call tact?
> You're as subtle as a brick in the small of my back
> So let's end this call and end this conversation"

—Brand New, "Seventy Times 7"

While fans of Taking Back Sunday were probably also fans of Brand New, there came a point in time when they likely kept it a secret. After some personal beef between the bands, fans felt the need to pick a side. Which one would you defend to the death in heated discussions with other emo kids? It was a big split in the scene, especially locally, and that fact is glaringly obvious across their records.

So why did they hate each other? The details are hazy, but the gist of it is so stereotypical it almost hurts: the feud was over a girl. Who is to blame for what betrayal has been a matter of contention over the years, but what isn't up for debate is the fact that it shook the bedrock of emo. Even if you didn't care about the drama—which was, frankly, very *Real World* (or for the newer generation, *Jersey Shore*)—you couldn't ignore it. The resentment

Brand New Cafe Del Sol Scranton PA Feb 2002

between the two bands fueled the writing of many of their songs, most notably "There's No 'I' in Team" by TBS, which uses a snippet of Brand New's equally scathing (and exceptionally violent) "Seventy Times 7" as a backtrack. The two go back and forth swapping searing insults and getting especially vengeful when it comes to trying to define what friendship really means. There were no veiled messages; direct attacks only.

> "Best friends means I pulled the trigger
> Best friends means you get what you deserve"

—Taking Back Sunday, "There's No 'I' in Team"

The products of this feud were brilliant, mind-blowing records that ended up being stalwarts of the emo canon. It may have been brought on by pettiness and rage, but what can you say other than that the best music is hardly ever made by the joyful.

One thing you could always count on was the constant change in the Taking Back Sunday lineup. After *Tell All Your Friends* was released by Victory Records, the same group of guys wasn't touring in support of it.

Fred Mascherino: "I was in the band Breaking Pangaea. We would play with Brand New, Taking Back Sunday—everybody. Then those guys, especially Taking Back Sunday, started to catch on and get bigger and then they would bring us out on tour. It was their first big tour, *The Takeover Tour*, and My Chem was on part of that tour. The end of that tour is when John [Nolan] and Shaun quit. I was shocked. We started asking around, 'Are they gonna keep going?' Apparently they were. I really didn't consider

Brand New Cafe Del Sol Scranton PA Feb 2002

doing it right away. I had actually talked to Chris Carrabba about playing in Dashboard at one point. I kidn of let that go. I found out I was having my second kid and I was thinking I was probably gonna go get a job or something, [which] was the last thing I wanted to do. I was at my parents' house and my mom said, 'Aren't there any bands that need guitarists right now?' So that night I called Eddie and I was like, 'What's going on with the try out?' And he was like, 'Yeah we're trying some people out, we've got people lined up. Why, are you interested? Look, if you wanna be the guy, we'll call everybody else and tell them to go away and you can just be in the band.' I was like, 'Nope. I wanna try out and I wanna beat the other guys.' I didn't have a copy of their record handy, so I went to a twenty-four-hour Walmart and bought the CD. I stayed up 'til like six in the morning learning all the songs."

Eddie Reyes: "The next thing you know, kids are coming up to us saying we're influencing them. Now people look at us like we're icons. But really, there are bands way before us that were icons. We just carried on the torch. There was that age of Yellowcard and My Chemical Romance, The Used, Coheed and Cambria—there was this chunk of us that were always on tour together. Back in 2000 to 2005, there was our genre of bands that were ruling the world."

Aaron Gillespie: "Every Friday night, my dad would get drunk and listen to this huge vinyl collection. He would drink Coors Banquet beer and get really drunk—this was my introduction to rock music. He would play The Beatles and The Stones and Zeppelin and The Eagles, and, to me, that was the first guitar music I heard and it was so big. It would feel like something you couldn't attach to. Like,

Brand New Cafe Del Sol Scranton PA Feb 2002

these people are gods. But when I was ten, I discovered stuff like The Cure and Nirvana. And that was like permission. It was messy and loud and kind of irreverent, and it gave us kids permission to be like, 'Oh, we can try to do this.' And that's literally what it was like with Taking Back Sunday and Thursday and Thrice and other bands that came before us that paved the way. That late 1990s/early 2000s emo scene was someone giving us permission finally. That was the best thing about it: it gave us all guts."

Fred Mascherino: "It was a very exciting time. [My son] was born during my first tour, and I had to fly home the day he was born. Then I had to make it to the show that night in Boston and flew back up."

After touring on Taking Back Sunday's debut record, Mascherino helped write records two and three, *Where You Want to Be* (2004) and *Louder Now* (2006). But before we delve further into Taking Back Sunday's story, there is another monumental emo artist that needs to be talked about in relation to the development of the genre at the turn of the millennium: Chris Carrabba, a.k.a. Dashboard Confessional.

A lot of people who became fans of Dashboard Confessional in the mid-to-late 2000s still aren't aware that Carrabba actually got his start playing in the formative emo band Further Seems Forever. And Further Seems Forever was originally a hardcore band.

Chris Carrabba: "They were in this band called Strongarm. It was a lot like Underoath or Poison The Well or Shai Hulud. I was in this other band, and we would play shows together. Strongarm had this traditional hardcore sound,

this incredibly ferocious roaring scream. I think the guys started thinking about music differently, and when Chris [Carbonell] decided he was gonna quit—he was like the third singer of Strongarm (or fourth, maybe)—I don't think they wanted to go through that again. (I think that would be a repeating theme for those guys because then it was three singers for Further, too.) They decided they were gonna start a band that wasn't a hardcore band. That was kind of the extent of the plan. They felt they pushed the boundaries of hardcore, and I think they did. They kind of redefined it in their way and are in a lot of circles considered almost legendary for that. And they were ready to do something different."

So Strongarm rebranded themselves as the melodic, yet still rough-around-the-edges Further Seems Forever. The lineup was exactly the same except for one crucial thing: they needed a new vocalist. Carrabba, who was part of the hardcore scene in Florida as well, was invited to try out for the new band and, sure enough, the lineup was complete.

Further Seems Forever's 1999 single, "Vengeance Factor," made it onto the fourth installation of Deep Elm Records' *The Emo Diaries*, a series of compilation albums featuring exclusive and unreleased songs from over a hundred emo bands. The first record that Further set out to create was *The Moon Is Down*, which ended up being released in 2001 via Tooth & Nail Records (MxPx, Underoath, Emery, Norma Jean). *The Moon Is Down,* easily one of the best emo records ever made, was not the only music Carrabba was working on at the time, however.

Chris Carrabba: "Josh [Colbert] was probably the main writer and then we all wrote supplementally. We all brought in songs, but generally speaking, Josh's songs

were the best ones. You might bring a song in and I might bring a song in, but if Josh brought a song in that day you were no longer as excited about your song just knowing that he had one, because you knew it was going to be better than anything you'd ever written or ever would. I did bring them Dashboard songs, and they essentially passed on them. They were like, 'This is really great. We're not gonna do it, but there's something here.' They kept asking me about the songs. I was like, 'Why do you keep asking me about these songs that we aren't gonna do?' And they said, 'Because they're really good.' I kept writing them. I had the songs, and Further was taking a long time to write *The Moon Is Down*. I had the original two days that we were going to go in and demo with James Wisner. They weren't ready, but James said, 'You can still have it.' So I went in and I recorded *The Swiss Army Romance*."

Carrabba's 2000 solo record was an instant gamechanger, both for the scene and for himself. The rest of the guys in Further knew he had done something special, and Carrabba did, too.

Chris Carrabba: "I think I knew pretty quickly that something was different. I knew something was special. I knew that there would be some people who would listen to this and really get it: really understand it and feel it. I certainly didn't know how many people. I felt so deeply myself about it that I was eager to see how it connected with [others]. I was an oddball, visually. When somebody walked in, they were like, 'He doesn't look like a hardcore kid.' I am one. There weren't hardcore kids playing acoustic guitar back then. I think that made people instantly curious or instantly hate me. Probably for life, too."

He's right. It didn't take long for people to be curious about and love Dashboard Confessional. And, as history would have it, he still had a large part to play in the coming years and in the continuing emo narrative.

$ 15.00 GEN ADM STANDING 15.00

6.25

SECTION/AISLE

GA

GA 5X

ROW SEAT

GA4 233

KJ103

NOV05

WWW.STARLANDBALLROOM.COM

HAWTHORNE HEIGHTS

STARLAND BALLROOM

SAYREVILLE, NJ

SAT DEC 3, 2005 6:10PM

PV0814 GA GA0 296 J-TVP

EVENT CODE SECTION/AISLE ROW/BOX SEAT ADMISSION

$ 30.25 GEN ADMISSION 30.2

7.25

SECTION/AISLE

GA

CA 46X

ROW SEAT

GA0 296

ORJ104

12AUG05

SAMSUNG & CINGULAR PRES

VANS WARPED TOUR '05

 * * * *

OLD BRIDGE RACEWAY PARK

ENGLISHTOWN, NJ

SUN AUG 14, 2005 DRS 11A

STANDING ONLY

BRAND NEW

EVENT CENTER

BORGATA CASINO, HOTEL AND SPA

Emo by Region

AZI

DOORS OPEN AT 8PM

TION of LONG ISLAND
L. I. (516) 225 5797 or 5700
AND CENTRAL PKWY
O SOUTHEN STATE PKWY EAST.
TE 109). PASS 1ST LIGHT,
PWAC IS ON RIGHT.
PARK IN REAR, ENTER ON SIDE
RN STATE WEST TO EXIT 34.
HT ONTO RT. 109, SEE ABOVE.
ARDS NEW YORK.
ARDS LONG ISLAND.
NS TO CROSS ISLAND PKWY
ECTIONS
PLE WITH AIDS COALITION!

UTOPIA (516) 935 6680
ON RT. 106 IN HICKSVILLE
(NEAR BROADWAY MALL)

PTEMBER 21st

FUGAZI

ALL AGES NO ALCOHOL DOORS OPEN AT 8

at the PEOPLE WITH AIDS COALITION of LONG ISLAND
1170 ROUTE 109, LINDENHURST, L. I. (516) 225 5797 or 5700
DIRECTIONS: L.I.E. / NO. STATE / GRAND CENTRAL PKWY
TO CROSS ISLAND PKWY SOUTH, TO SOUTHEN STATE PKWY EAST
SOUTHERN STATE TO EXIT 33 (ROUTE 109). PASS 1ST LIGHT,
FOLLOW RT. 109 BARELY 1/4 MILE, PWAC IS ON RIGHT,
CORNER OF RT. 109 & ALBANY AVE. PARK IN REAR, ENTER ON SID
FROM EASTERN L.I. TAKE SOUTHERN STATE WEST TO EXIT 34.
LEFT AT EXIT, ANOTHER LEFT AT LIGHT ONTO RT. 109, SEE ABOVE.
FROM OTHER PLACES RT. 95 TOWARDS NEW YORK.
TAKE THROG'S NECK BRIDGE TOWARDS LONG ISLAND.
ONCE OVER BRIDGE, FOLLOW SIGNS TO CROSS ISLAND PKWY
SOUTH. THEN FOLLOW ABOVE DIRECTIONS
PROCEEDS WILL BENEFIT THE PEOPLE WITH AIDS COALITION!

**TICKETS ARE AVAILABLE FOR $5.00
AT THESE LOCATIONS:**
(ON LONG ISLAND)

NONE OF THE ABOVE
ON MIDDLE COUNTRY RD. (RT.25)
IN CENTEREACH (516) 737 9350

UTOPIA (516) 935 6
ON RT. 106 IN HICKSVI
(NEAR BROADWAY MA

THURSDAY, SEPTEMBER 21s

AZI

DOORS OPEN AT 8PM

TION of LONG ISLAND
L. I. (516) 225 5797 or 5700
AND CENTRAL PKWY
O SOUTHEN STATE PKWY EAST,
TE 109). PASS 1ST LIGHT,
PWAC IS ON RIGHT.
PARK IN REAR, ENTER ON SIDE
RN STATE WEST TO EXIT 34.
HT ONTO RT. 109, SEE ABOVE.
ARDS NEW YORK.
ARDS LONG ISLAND.
NS TO CROSS ISLAND PKWY
ECTIONS
PLE WITH AIDS COALITION!

FUGAZI

ALL AGES NO ALCOHOL DOORS OPEN AT 8

at the PEOPLE WITH AIDS COALITION of LONG ISLAND
1170 ROUTE 109, LINDENHURST, L. I. (516) 225 5797 or 5700
DIRECTIONS: L.I.E. / NO. STATE / GRAND CENTRAL PKWY
TO CROSS ISLAND PKWY SOUTH, TO SOUTHEN STATE PKWY EAST
SOUTHERN STATE TO EXIT 33 (ROUTE 109). PASS 1ST LIGHT,
FOLLOW RT. 109 BARELY 1/4 MILE, PWAC IS ON RIGHT,
CORNER OF RT. 109 & ALBANY AVE. PARK IN REAR, ENTER ON SID
FROM EASTERN L.I. TAKE SOUTHERN STATE WEST TO EXIT 34.
LEFT AT EXIT, ANOTHER LEFT AT LIGHT ONTO RT. 109, SEE ABOVE.
FROM OTHER PLACES RT. 95 TOWARDS NEW YORK.
TAKE THROG'S NECK BRIDGE TOWARDS LONG ISLAND.
ONCE OVER BRIDGE, FOLLOW SIGNS TO CROSS ISLAND PKWY
SOUTH. THEN FOLLOW ABOVE DIRECTIONS
PROCEEDS WILL BENEFIT THE PEOPLE WITH AIDS COALITION!

**TICKETS ARE AVAILABLE FOR $5.00
AT THESE LOCATIONS:**
(ON LONG ISLAND)

NON OF THE ABOVE **UTOPIA** (516) 935 6

New Jersey and New York

While other areas of the US were certainly experiencing their own emo uprisings, there was no scene as rich as the one growing in New Jersey and New York. The two states have always been siblings of sorts, living in close proximity of one another, boisterously picking on each other, and quietly loving each other. We share a lot of the same things: ideals, cultural diversity, sports teams (you know that most of the athletes on New York teams live in, practice in, and even play in New Jersey, right?), a generally cynical view of the world, and a blistering sense of sarcastic humor that makes residents of other states think we're assholes. And, of course, we share tragedy, like the unforgivable events that took place on September 11, 2001.

After the punk movement had taken root in New York City in the 1970s, it was really just a matter of time until the next counterculture came around. Hardcore hit NYC in the 1980s with bands like Agnostic Front, Cro-Mags, Leeway, and Youth Of Today, but hardcore never became quite as celebrated in the public eye as '70s punk was (although it deserves the same attention). But then 1990s emo came around, and, before long, places like Long Island, New York, and New Brunswick, New Jersey, became emo breeding grounds whose music and values would reverberate throughout the rest of the country.

Eddie Reyes: "It's just growing up in Long Island or in Brooklyn or Queens, or if you're in Jersey and you're in Union and New Brunswick, it's the area that surrounds you; the different cultures, the different music in the air, the different beats that get stuck in your head when

you're standing on the corner. What is it, like twelve million people in a ten-mile radius? Like shit, something's gonna happen. It's just in the water. You know how they say it about the pizza and the bagels? Something imprinted in our heads. Something about hanging out in a parking lot with your friends and listening to music… something happened."

Fred Mascherino: "Especially New Jersey. That had a rich basement scene."

Garrett Zablocki: "We always talk about that. I don't know what it is. There's a lot of culture here. It seems like every band on the top-ten list is from this area."

I myself am sincerely proud to be from New Jersey, not out of some inflated sense of superficial self-righteousness, but because much of the world's greatest music was born right here. (Remember, too, that we gave you Frank Sinatra.) It is a truly special thing that everyone I know has firsthand accounts of this scene's best basement and VFW shows, like that one time they opened for *this* band that made it big or that other time when *that* vocalist was a total dick but is now a favorite name-drop story. In 2019, you'd have a hard time paying your friends to show up to your local band's VFW show, but back then it was all anybody cared about. The teenage masses were crawling from basement to basement, showing up without even knowing which bands were on the bill that night. If you were a band in the late 90s and early 2000s, you wanted to get in tight with the New Jersey crowd. To get an idea, just watch ten seconds of *Bastards of Young* (a 2005 DVD documentary directed by Shannon Hartman and produced by Michelle Caputo).

Aside from the sheer population density of New York and New Jersey, I personally think that the emo explosion in this area was largely due to the fact that most people here aren't very happy. Let's be real, nobody includes New Jersey on their happiest-places-to-live list, and New Yorkers are so firmly cynical that saying hello to a stranger is a social taboo that is justifiable cause for suspicion. It's no coincidence that the biggest heroes of the genre, My Chemical Romance, came from Newark—a New Jersey city with one of the worst crime rates and reputations.

Chris Carrabba: "I have a memory of playing with Thursday at Montclair State University in the cafeteria with the lights on, and the only two people that came to see us were Mikey and Gerard Way. Bands that came out of there gave a dynamic shift to the weight of what we were all doing and how much we were all willing to invest."

Garrett Zablocki: "Us and My Chem, we would always be put on shows together. And then, finally, when both bands got signed and we were actually doing real touring, we shared a bus together and did a co-headlining tour."

Fresh Mascherino: "What I loved was being friends with all the other bands. There are so many classic records I got to hear before anyone else heard them because they were my friends. When My Chem came out with *Three Cheers*, they brought the CD right when it was mixed and were like, 'We want you guys to hear our new record. We want to know what you think.' And we did the same thing with them."

My Chemical Romance is probably the best example of why the New Jersey and New York emo and screamo

scenes were as substantial as they were. At this point, the story has all but become legend, but here it goes:

It was because Gerard Way witnessed the Twin Towers come down in the 2001 terrorist attacks that he quit his role at Cartoon Network and started focusing on music and MCR full-time. Just like any kid who'd grown up in New Jersey, he'd gone to college and started the process of commuting to work in the city every day for his new adult life. But in the span of one day—*that* day—Way realized, as many others did, that life was too fleeting and fucked up to waste time going through the motions.

The experience of watching the towers burn and fall, hearing the screams and cries of fellow New Yorkers, and feeling the ash and debris descend from above would be the catalyst and remain the central theme for his music and art for the rest of his career. When he left Cartoon Network and immediately formed My Chemical Romance, one of the first songs the band wrote was "Skylines and Turnstiles," describing the horrors of the events he witnessed that infamous day in 2001. Years later, the music video for the band's mainstream anthem, "Welcome to the Black Parade," would visually recreate the despair, grey skies, ash, and architectural debris against the backdrop of a city skyline, like the scene that had unfolded years prior in New York City.

Similarly, Buddy Nielsen of Senses Fail told *Alternative Press* in 2017 that the New Jersey scene's experience with 9/11 was a significant reason for why they sounded the way they did:

"I think that a lot of the music that grew out of New Jersey, New York, the tri-state area, in some respect, was a

reaction to 9/11. For me personally, it happened my senior year in high school, and I didn't really know how to react to it. After that happened, I didn't really know what to do, and Senses Fail came along. Those existential questions, I put into Senses Fail. I think a lot of other people did that as well. I do think that the music scene, the popularity of it in the location of where we were, played into why the bands in that area were able to harness whatever sort of emotional current was happening. The music scene in New Jersey and the DIY perspective, that was huge. That doesn't exist everywhere. I think that's one reason that we exist."

"Skylines and Turnstiles"

You're not in this alone
Let me break this awkward silence

Let me go!
Go on record
Be the first to say I'm sorry
Hear me out
And if you take me down
Would you lay me out?
And if the world needs something better
Let's give them one more reason now

We walk in single file
We light our rails and punch our time
Ride escalators colder than a cell

This broken city sky
Like butane on my skin

Stolen from my eyes
Hello angel, tell me
Where are you?
Tell me, where we go from here
And in this moment we can't close the lids
On burning eyes
Our memories blanket us with friends we know
Like fallout vapors
Steel corpses stretch out towards an ending sun
Scorched and black
It reaches in and tears your flesh apart
As ice cold hands rip into your heart

That's if you've still got one that's left
Inside that cave you call a chest
And after seeing what we saw
Can we still reclaim our innocence?

Despite the fact that most people wish 9/11 had never happened, it was one of the elements that played a major role in the emotional turmoil that emo bands and their fans were going through at the time. The air was heavy and sad and angry, and so were many of these records.

Shane Told: "I will say that the regional movement of the scene was really, really important. That's something that's lost now—completely lost. You heard a band back then in the early 2000s, you could tell almost by how they sounded where they were from. When you talk about Taking Back Sunday or—I guess I have to bring them up—Brand New, they were both from New York and sometimes they sounded like they could be the same band. Then you had Thursday and you had Armor For Sleep and then you had Senses Fail, then one of

my favorite bands from New Jersey from that era called Penfold. New Jersey was a huge scene. What happened was there were different pockets all over the place where this music was thriving, and New Jersey was one of them. We looked at places like New Jersey, and there were all these bands coming out with this kind of sound. The music was kind of harder to stomach in so many ways, so I was excited about that."

Even bands from other states, like The Starting Line from Pennsylvania, would make the trek to New Jersey to play shows and be part of this incredibly fertile scene.

Kenny Vasoli: "There was this circuit of VFW and moose lodge shows, especially in New Jersey, that was really accepting of this kind of sound when we were making it. It was a lot of New Jersey bands, like Hidden In Plain View, that we were doing shows with. It was a tough sell in Philly at the beginning. It was a big hardcore town. At first, [New Jersey] was definitely where we were embraced and where we began to make our name."

Chris Conley: "Everyone was just friends. Kids from high school, kids from college. Rutgers was in New Brunswick, and there [were] a lot of cool bands at Rutgers. The Melody Bar at New Brunswick was an amazing place to play. Then it just all started to happen."

Chris Simpson: "I played this one basement show in New Brunswick, New Jersey, and it was just so much fun. I don't know if there's anything more fun than that."

Eddie Reyes: "So many bands from Jersey, like Lifetime and Thursday and Turning Point, helped build that scene. There wouldn't be a Skate & Surf [without them]. There

wouldn't be a Bamboozle or any of those festivals going on if it wasn't for our scenes doing all that."

While they were similar, the New York scene did have its own story. While basement shows were ubiquitous in suburban New Jersey, New York musicians were feverishly booking hardcore shows at local venues (as they still continue to do to this day) and building the would-be emo scene from there.

Eddie Reyes: "The Long Island scene was basically me and six other dudes. We started booking shows, playing in bands, and slowly the scene built up. We were just finding different places to play shows, like the Right Track Inn in Freeport. The P.W.A.C. was one of them. It was a venue my friends and I started running out of a warehouse in Lindenhurst, and the shows just started blowing up. The next thing you know, we had Fugazi playing."

Chris Conley: "When you listen to Gorilla Biscuits, they have this melodic sound and they're singing about feelings, but it's New York—aggressive, angry. In New Jersey, you're not on the city streets walking around getting elbowed out of the way. You're sitting in a field under the stars at night, and you're alone with your feelings."

Eddie Reyes: "Long Island kind of had its own style of sound. We were hardcore kids, but then we were like, 'let's be a little more melodic.' That's why Glassjaw was this tornado of emotion and sick riffs and Daryl's amazing vocals. Then you had Tom who sang for A Silent Majority. Then you had Brand New. It got to the point where labels were jumping in little buses and coming up to Long

Island to go to shows to watch bands. We were like the next Seattle."

New York and New Jersey weren't the only places where emo was thriving, but the scene and the genre as we know it would not be the same if it weren't for the bands from these states, both in terms of quality and just sheer volume.

Midwest

While many point to New York and New Jersey as the champions of emo (rightfully so, I think), there were other areas of the United States that grew some legendary bands as well. With bands like The Used, Hawthorne Heights, Story Of The Year, The Get Up Kids, American Football, and Christie Front Drive in the mix, the Midwest had their own claim to stake in the development of emo.

Matt Pryor: "We started discovering these bands like Jimmy Eat World and Braid, and The Promise Ring was a big deal for us. We were like, 'Oh, this is just pop music.' With the exception of Jimmy Eat World, those bands from the Midwest…I think there's a common sensibility of people from this area. It's more laid back than the East Coast, that's for sure. New Jersey is *not* laid back. The Midwest was probably more pop music-oriented and less punk and less hardcore."

Ethan Fixell: "Mineral, even though they didn't come from a punk/hardcore background, inspired the entire Midwestern Emo sound—those slow, longing, painful tunes with gorgeous guitar passages and strained vocal melodies. *EndSerenading* is one of my all-time favorite albums."

Steve Lamos: "I think Cap'n Jazz was a pretty important band. I remember the first time I saw them was in Danville. I didn't know Mike, but I went with some friends from the University of Illinois, and it was this amazing experience. We were at the back of this bar watching them play, and that was my exposure to what emo meant. I think what he and his brother were doing in that band was, to me, the epitome of what that emo stuff could be. And then Braid. I also associated them with that scene. Those bands from the northwest suburbs of Chicago [had] their influence on that era. It was just a time and a place: University of Illinois, Champagne, Urbana in the mid 1990s. That's the sound that came out when we tried to channel it. I was so in love with the Champagne scene. Hum and Poster Children, oh god, those bands meant so much to me. The Midwest emo thing sort of intersected with that but sort of didn't. It was kind of like a bunch of the Chicago suburb kids came down to Champagne to go to school, and they brought their music with them. Then they went back and did their music elsewhere. Whereas Champagne had its own indie-rock identity. There was a band called Caster. There was a band called Sea Clamp. Those bands meant the world to me. Polyvinyl is still there and they've been there for twenty years."

There was no family more influential in the Midwestern emo scene than the Kinsellas. Joan of Arc, Cap'n Jazz, American Football—it's like emo music was the family business. These bands can be especially credited with aiding in the formation of the genre.

The 2000s would see the arrival of some extremely iconic screamo bands, including one of the crown jewels of the genre, The Used. Their records *The Used* (2002) and *In*

Love and Death (2004) were neck-and-neck in popularity and influence with My Chem's *Three Cheers for Sweet Revenge*, which also came out in 2004. Like My Chemical Romance, The Used would end up becoming synonymous with the genre itself.

Canada

Emo and screamo are generally viewed as a product of the United States, but the importance of Canadian bands such as Grade, Silverstein, and Alexisonfire cannot be understated. Think of emo and screamo music as having the same kind of structure as the National Hockey League. There are the Metropolitan, Atlantic, Central, and Pacific Divisions, and, while the majority of teams are based in the US, the NHL wouldn't be the NHL without Canadian teams like the Toronto Maple Leafs or the Winnipeg Jets, etc.[6] Some of the most essential songs on your playlist are from Canadian heavy-hitters.

Shane Told: "Where I'm from in Canada, we had [a scene] too. Some of the bands that came out of our area were Monine, Boys Night Out, Alexisonfire, Billy Talent. Sum 41 was down the street, even though that was pretty different. We all were playing shows in the Toronto area. It didn't matter who was playing; you were having two to three hundred people coming out just to see local bands. Music was so important in these regions and what happened was bands would hang out together and influence each other. There's no question that the reason that us and Boys Night Out and Alexisonfire have similar sounds is because we grew up literally within a

6 I realize that for some of the artistic demographic reading this book, a
 sports analogy is probably less than helpful. But let's give this one up for the
 Canadians, cool?

fifteen-mile radius of each other. Nowadays, I don't think that exists."

Silverstein in particular is a band that this genre could not have done without. If one were to assemble a list of the most iconic emo and screamo songs, there is no question that at least "Smile in Your Sleep" and "My Heroine" would make the cut.

Shane Told: "What was kind of funny was the song that I thought (and everybody thought) was the hit was "Smile in Your Sleep." Everything was firing on all cylinders. Then, about a couple weeks after the album was out, everybody's talking about this song "My Heroine." It was track seven, which was a song I wrote myself that I thought was really special. I was really proud of it, but the band wasn't feeling it. The producer wasn't feeling it to the point where one day when we were recording the record, the producer pulled me aside. So I put it at track seven, not really explaining to them that this was going to be the first song on side two of the vinyl. I did that on purpose. No one in the band even knew how to play it except me. That was the song that cemented us into this thing, and it put us into the same category as the other greats that had put out great albums two or three years before us."

South

Most people don't think of the South when they think of the emo scene, but there were bands such as At the Drive-In (Texas), MAE (Virginia), Further Seems Forever, Dashboard Confessional, and Underoath (Florida) that came out of that region of the United States. Florida has been the main incubator for Southern emo, screamo, and -core bands, churning out acts (other than those already mentioned) such as A Day to Remember to Mayday Parade to The Red Jumpsuit Apparatus. But while the South isn't known for as many emo bands as, say, New Jersey, the ones that did come out of that area were hugely important to the genre.

Jacob Marshall: "Being inside of it, it felt so slow. In hindsight, it was incredibly fast. It felt slow because when [*Destination: Beautiful*] came out, it was February of 2003, and we had been on tour for several months. We just went as hard as we possibly could. We were just committed. This was our life now. I remember one night, we played in this little town in Illinois, and we had seven people show up. But those seven people couldn't even get into the venue because they were underage, so there was literally no one there to watch. It was one of those moments that you were like, 'Is this really my life right now?' You know, you graduate from college with honors and you're living in a van, starving, playing to no one in a bar in Illinois. It was such a funny, extremely depressing moment. 'Have we just made an enormous mistake?'

"But after…that tour, we were home for about a week. During that week, I remember feeling so excited to see family and friends, but at the same time it was like I was a

Further Seems Forever Tulagi Club Boulder CO March 2002

visitor at home. That feeling of home actually had moved to being in transit. Climbing back into the van after that week, I was home. For the next decade, we would tour as hard as any band I know. We did over 1,600 concerts in ten years. For the first couple years, we were doing between 260 and 300 dates a year. Our big break came when we were invited to join the Something Corporate tour that fall, 2003. We were on that with a band called Days Away that we love, and The Format. We were playing for 1,500 to 2,000 people a night."

Chris Carrabba: "We were culturally and geographically isolated way down in Florida. We had to make our own bands. But the thing that was great about that was there happened to be some incredible players. There was an insatiable appetite for music. I think that the fact that we were isolated raised the bar of what we expected from each other in terms of quality."

Aaron Gillespie: "When we made our first EP, we were living in South Florida in this guy's apartment, James Wisner, who actually wound up doing *They're Only Chasing Safety*, our first real record. He had just got the Further Seems Forever record with Chris [Carrabba] singing. We were actually staying in Chris's house. Chris rented the top floor of this house from this lady in Fort Lauderdale, and she let us all stay there. And I remember Chris giving me *The Swiss Army Romance* on a burned CD. I was like, 'Holy shit.' I just knew when he gave that to me that Further Seems Forever was done."

Chris Carrabba: "Let me set the record straight on exactly where they crashed. I may have told them that was my place, but I was a boarder at a house with three or four other people, and they all happened to be out of town.

Further Seems Forever Tulagi Club Boulder CO March 2002

I just liked the band so much I just let them stay there. [But] that's an interesting correlation, because I didn't have any intention of leaving Further Seems Forever. I think if I'd had it my way, I'd still be in Further Seems Forever. I don't think Dashboard was the end of Further. The Further guys were the beginning of Dashboard. They really pushed me to pursue this, even while I was doing Further. They just believed in me, which was such a nice thing because I looked up to those guys. To be invited to be in the band with those guys was a huge deal."

So, while in a geographical sense the South wasn't as prolific or significant to the genre as some of the other regions were, Dashboard Confessional and Underoath would end up becoming two of the biggest artists associated with emo and screamo in that music's history.

Further Seems Forever Tulagi Club Boulder CO March 2002

West

The West was kind of like the South in the sense that it wasn't the focal point of emo, but it made its contributions. Southern California had always been a key player in hardcore, punk, and rock, from Bad Religion to Mötley Crüe to blink-182. Los Angeles is, after all, the entertainment and media capital of the world (next to New York City). Half of rock history would be erased from the books if you took away the words "Hollywood" or "Sunset Boulevard." Emo, though, was much too subdued for the typical Californian taste. Say Anything, Sense Field, and Saosin were from the Golden State, but the biggest contributions the West Coast made to emo were not from California. Sunny Day Real Estate and Jimmy Eat World were from Washington and Arizona, respectively.

So what's the purpose of mapping out the genre, anyway? It's not just to fuel your emo trivia knowledge (which, if that ever comes up in a way that is useful, please let me know), or to rank the importance of one state over another. It is to recognize how much of a regional movement this was as well as a national movement. The golden ages of emo and screamo were the last time that local punk scenes were so incredibly lively. As Shane Told mentioned earlier, that really doesn't exist anymore. There is not nearly as much of a focus on local musical communities as there used to be. Part of that can be attributed to the evolution of the internet, which made an artist's location a virtually useless detail since their music could be heard instantly and anywhere. But knowing where these '90s and 2000s bands came from is integral to knowing their sound and their history.

$ 15.00 GEN ADM STANDING 15.00
 6.25 WWW.STARLANDBALLROOM.COM
SECTION/AISLE
GA HAWTHORNE HEIGHTS
GA 5X
ROW SEAT
GA4 233 STARLAND BALLROOM
OKJ103A SAYREVILLE, NJ
22NOV05 SAT DEC 3, 2005 6:30PM

PY0814 GA GA0 296 J-TVP
EVENT CODE SECTION/AISLE ROW/BOX SEAT ADMISSION
$ 30.25 GEN ADMISSION 30.25
 7.25 SAMSUNG & CINGULAR PRES
SECTION/AISLE
GA VANS WARPED TOUR '05
CA 46X * * * *
ROW SEAT
GA0 29C OLD BRIDGE RACEWAY PARK
ORJ104J ENGLISHTOWN, NJ
12AUG05 SUN AUG 14, 2005 DRS 11A

 STANDING ONLY

 BRAND NEW

 EVENT CENTER
BORGATA CASINO, HOTEL AND SPA

You're Cute When You Scream(o)

Screamo is one of my absolute favorite genres (or subgenres, if you want to be technical about it), but I admit that I felt the same way about the term "screamo" as many musicians felt about the term "emo". Growing up surrounded by preppy kids, any topical knowledge they had of bands with any type of unclean vocal was blanketed by the term "screamo". When people used that descriptor, it felt as if they were cheapening the music by reducing it to its most basic characteristic. In my mind, there was so much more to screamo than just laying screams down on a track, because, by that logic, virtually any metal band could be called screamo.

But a decade later, I, like many others, concede that there is no other way to describe bands like From Autumn To Ashes, Silverstein, or From First To Last than "screamo."

Dan Marsala: "We were just lucky enough to be in some genre that ended up being called screamo. We hated that term for a long time. Now, we look back and it's like, 'yeah, that's what it is.' "

What 2000s screamo bands and fans of those bands, like myself, mean when they talk about the genre is different and a little more complex than the preppy kids at school would have it though. When describing 2000s bands like Story Of The Year, Chiodos, Senses Fail, and A Static Lullaby as screamo, we're talking about a type of music that branched out from standard 'emo' bands like Sunny Day Real Estate and The Promise Ring. While 'emo' did possess a certain type of edge and tension, screamo took those qualities and set fire to them under a magnifying glass.

Ian MacKaye: "Emo went through an evolution. There were these bands where kids were really laying it out there, like screamo. That "screamo" thing was so over the top."

"Over the top" can be a negative review of the emo subgenre, but it's also not inaccurate. These bands *were* taking emo over the top—that was kind of the point. There was rage that needed to be expressed alongside the pain; it was the wolf finally baring its teeth. Screamo took the lyrical and emotional elements of emo and injected it with some of the hardcore punk elements that had been lost along the way.

It is commonly held that bands such as Saetia, Pg. 99, and Orchid were some of the first pioneers of screamo, but listening to those bands now, they have more in common with grindcore[7] than they do with the 2000s bands to which the word 'screamo' is typically attached. That's because, as I mentioned earlier, there is much more to what we think of as "screamo" than just screaming: it is the *type* of scream that defines this genre.

Hardcore screaming is assertive and dominant. The type of screaming found in screamo contains the emotional, painful elements found in emo music. Screamo screams contain melodic inflections in order to convey emotions other than just anger. These screams contain desperation, pleading, vengefulness, and sorrow. As with emo, screamo lacks the stereotypically masculine sound that tends to be associated with hardcore music. The band that best showcases the evolutionary step between bands like Saetia and bands like Senses Fail is probably Circle Takes

7 Grindcore is a type of hardcore music that features chaotic instrumentation and time signatures, as well as wild, howling, usually unintelligible screams.

The Square. In their song, "Non-Objective Portrait of Karma," the unclean vocals sound pretty grindy, but as the song progresses and the tempo slows, they morph into half-speaking, half-screaming vocals that sound more in line with the modern definition of screamo.

2000s screamo also places more of a focus on dividing songs pretty equally between clean and unclean vocals. In this respect as well, bands like Madison and their 2004 record *For The First Time In Years...I'm Leaving You* are worlds away from Pg. 99's many *Documents*. 2000s screamo also reached a point where it became nearly synonymous with post-hardcore. However, fans that grew up on Glassjaw would probably punch you if you put them in the same category as Silverstein or Alexisonfire.

Now, some would venture to call Underoath a screamo band. The majority of the band's discography (*Define the Great Line, Disambiguation, Lost in the Sound of Separation*) suggests that they are more of a metalcore band, but their early records, like *The Changing of Times* (2002) and especially *They're Only Chasing Safety* (2004), can be placed into the screamo category. Ultimately, though, I think it is a waste of time to try to classify Underoath, partially because they experimented with so many sounds, but mostly because I think they belong to a class all their own. They have toured with, influenced, and been respected by bands from underground emo all the way to radio rock, which is why, despite them not being emo in the purest definition of the word, an accurate picture and history of the genre cannot be made without them.

Reflecting on it now, screamo actually made up the majority of the emo music that broke through to

mainstream music culture (despite radio edits removing the screams from the songs they played). More screamo bands made it to MTV and arena shows than emo bands ever did. That's likely because screamo was more boisterous, brash, and brazen. Pop sensibilities and catchy hooks were also as much a part of 2000s screamo as the hardcore and emo aspects were. This combination of sounds is what appealed to a great number of kids—and record labels.

In the late 2000s and the 2010s, screamo would essentially be replaced by melodic metalcore. If emo and screamo weren't just part of one's "teenage phase," then the next set of bands on their playlist would be Asking Alexandria, We Came As Romans, blessthefall, Motionless in White, and Of Mice & Men. Like screamo, melodic metalcore is split pretty evenly between clean singing and clear guitar riffing and screams, growls, and heavy instrumental breakdowns. In this genre, however, unclean vocals generally revert to more of an aesthetic than an emotional component.

$ 15.00 | GEN ADM STANDING | 15.00

6.25

SECTION/AISLE
GA

GA 5X
ROW SEAT
GA4 233

OKJ103A

22NOU05

WWW.STARLANDBALLROOM.COM

HAWTHORNE HEIGHTS

STARLAND BALLROOM

SAYREVILLE, NC

SAT DEC 3, 2005 6:00PM

FV0814 | GA | GA0 296 | J-TYP

EVENT CODE | SECTION/AISLE | ROW/BOX | SEAT | ADMISSION

$ 30.25 | GEN ADMISSION | 30.2

7.25

SECTION/AISLE
GA

CA 46X
ROW SEAT
GA0 296

ORJ104J

12AUG05

SAMSUNG & CINGULAR PRES

VANS WARPED TOUR '05

* * * *

OLD BRIDGE RACEWAY PARK

ENGLISHTOWN, NJ

SUN. AUG 14, 2005 DRS 11A

STANDING ONLY

BRAND NEW

EVENT CENTER

BORGATA CASINO, HOTEL AND SPA

I Wouldn't Front the Scene if You Paid Me

The birth of the internet changed human civilization forever. Once it stopped being a military secret and became a tool for the public to use, culture, art, and communication were irrevocably transformed. The music industry was no exception. As far as music or any other type of entertainment goes, the internet totally redefined how they operated. But before MP3s and illegal downloading killed the radio star, so to speak, the internet played a crucial role in bringing musicians and fans together.

In the '90s, the internet was still in a very primitive stage. But, as we know now, it wouldn't stay that way for long. It was only a short time before online forums and message boards became a new way for musicians to connect with one another and form bands. The reason Buddy Neilsen is in Senses Fail, for instance, is that he responded to guitarist Garrett Zablocki's message on the now defunct NJSka.com. Band profiles on MySpace and PureVolume made their music easily accessible to virtually anyone in any location. For the first time, fans could go online and connect with each other about what *Nothing Feels Good* or *EndSerenading* meant to them. A chick in Colorado could talk to a guy in New Jersey about what bands were coming in hot at the moment. And, not only could you hear The Promise Ring or Mineral's songs, you could see pictures of them instantly. The proliferation of musical information was all of a sudden going at warp speed, and at first, that was a very, very good thing for emo—especially the wave of emo and screamo bands that were coming out in the early 2000s.

Tom Mullen: "The internet was figuring its way, emo was starting to be in every conversation, and those

savvy nerds had this genre to figure out the internet with by way of Friendster, MySpace, PureVolume, and those great message boards to discuss/debate before we had everything in our pocket. Emo was right there at the cusp."

Babs Szabo: "I think MySpace was huge for this genre, because that's honestly how I found out about most of the bands that I ended up listening to, just because everyone could have a song on [their] profile. I think the two biggest things were your Top 8 and the song that you had on your page. I found out about Underoath and Head Automatica and The Almost through MySpace."

T.J. Petracca: "I think that MySpace made this moment in music feel more like a community. It was the first time that we got to really see behind the facade of how a band was photographed in magazines and stuff like that. You could actually go and see Sonny Moore's MySpace profile, and he would be posting mirror selfies from his Sidekick. That was never done before in music. I think that sort of connection with the fans was heavily due to the dawn of the internet. We kind of knew each other—other fans—through forums or through MySpace groups. People you'd see at shows, you could add them and stay in touch with them."

The internet was the most significant thing to happen to the music industry since the launch of MTV. Bands started gaining followers like crazy and the scene swelled to the point where it was impossible for label heads to not pay attention. After grunge, they were looking for the next big thing, and they were able to find it in emo.

Thursday hit MTV with "Understanding in a Car Crash." Hawthorne Heights made it with their white suits and black guitars in their "Saying Sorry" video. The emo scene pretty much lived on Fuse's *Steven's Untitled Rock Show*, which saw host Steven Smith interviewing bands from all of the festival circuits (*Warped Tour*, *Taste of Chaos*, *Bamboozle*, etc.) as well as inviting them to play live sets at the TV studio. Coming home from school every day to catch SURS is still very vivid in my memory. This guy was talking to all the bands I ever cared about, from Kill Hannah to The Used to 30 Seconds to Mars. He wasn't asking dumb questions of NSYNC or 98 Degrees. Steven was talking to real musicians about real shit. The fact that there was something that felt real about TV and pop culture was mesmerizing to me. It's something that's virtually unthinkable now.

Aaron Gillespie: "That gave us the ability to say, 'I wanna do this too.' The first thing I saw on MTV was that Thursday video. That, to me, was like, 'Oh shit, this is really happening.' "

Seemingly overnight, bands like Saosin, Thursday, Senses Fail, Coheed and Cambria, The Used, and My Chemical Romance got so big that they began playing stadium shows. They were the new, young breed of rock stars. By the time the first *Taste Of Chaos* tour kicked off in 2005, these once local bands were essentially pop icons.

Garrett Zablocki: "You had probably the most recognizable names of that scene and we were selling out arenas every single night. If you were to think about Rihanna going on tour, that's what it was for us. Our backstage was NBA teams' locker rooms. You didn't have to worry about selling out a show. It was a free-for-all.

Every day was like going to Disney World. It sort of felt like a traveling circus."

Aaron Gillespie: "It was massive. It was arenas. I remember thinking, 'What in the world?' We played twenty-something countries with Taking Back Sunday. We grew up making music in VFW halls and bars. Those times were surreal. None of us ever thought it could turn into that. None of us ever set out for it to be that way, and I think that was what was really special about that time."

Thursday Starland Ballroom Sayerville NJ 2004

Ryan Phillips: "2003 to 2005 was so magical for us because the emo/screamo thing reached its pinnacle, and we were at our biggest. We just kind of helped bring it to the mainstream in a way it hadn't before."

Shane Told: "I think the band that really changed it and the point you can really say there was a shift was Dashboard Confessional. [Chris Carrabba] was doing merch for Midtown, and he was opening for [them]. No one knew who he was. I was outside talking—I didn't see the performance—but what I know is people's minds were blown. This guy up there with an acoustic guitar. Somebody told me after that that Dashboard Confessional was their favorite band. I was like, 'Does he even have anything recorded?' But literally, that guy there in that moment with a guitar and the way he sang and the way he tuned the guitar and "Screaming Infidelity" and these lyrics, were so able to be embraced by the mainstream. It was so easy for people to get it."

Chris Carrabba: I wasn't doing merch for Midtown, I was doing merch for The Movielife, who was opening. So it was even one degree of separation further. They knew I was in Further Seems Forever. I was like well, I have this acoustic thing and I'm kind of on the road and I did a show with The Movielife, but I don't have any other shows so I'm just gonna hang out with them and do merch. [Midtown] was like, 'Oh, well why don't you play, too?' "

Thursday Starland Ballroom Sayerville NJ 2004

Matt Pryor: "There was this period in the early 2000s where everyone was just kind of in it to win it. Major labels were scooping people up and young kids were like, 'Yeah, I'm gonna be famous.' And I was just like, 'What the fuck does that mean? You're not gonna be famous, you're in a punk band.' "

Shane Told: "I thought the biggest a band could get without playing on the radio was maybe like The Ataris or something. I thought bands could play maybe one to two thousand cap rooms and maybe *some* band could sell 100,000 records. Then we did that. This movement was so huge that us just getting spillover from Thursday and Taking Back Sunday (because they were on MTV), and even just Victory putting a sampler CD of our music made a whole career for us. It was so easy to get eyeballs on it."

Thursday Starland Ballroom Sayerville NJ 2004

Thrice Owl's Cove Temple University Philly June 2002

Dan Marsala: "One of the first bands that we ever really toured with was The Used. Their record came out the year before ours, and they were kind of paving the way—them and Taking Back Sunday. We were just kind of following in their footsteps, trying to take it to the next level. That Used tour that we were on, Thrice was on that as well and My Chemical Romance, and we were opening. It was a crazy tour. Nobody knew any of our bands except The Used because their record was out, and they were doing pretty good. But it was like, five hundred capacity clubs. Now, it seems insane. But that was 2003, and we were all new bands."

Garrett Zablocki: "My Chem was on *TRL*, and that was totally owned by boy bands and Britney Spears before that. We were that trend in the early 2000s."

Chris Carrabba: "When I saw My Chemical Romance, I thought, 'That's a great fuckin' emo band.' I think they were one of the most important bands to come out of our scene, whether you called that scene 'emo' or whether you called it anything else. They never shrugged off where they came from and never pretended to be anything else."

Dayna Ghiraldi: "[These bands] were on the covers of all these magazines. It became this uprising of misfits; people who found a home within their music where they felt accepted. It felt like home. You felt an instant connection to people who liked this music."

The frenzied reaction to emo and screamo hitting the mainstream was absolutely unreal. Not only were bands making it to MTV and Fuse, but they were making it to late night TV with the likes of Jimmy Kimmel and Conan O'Brien. One of the most memorable performances of

that time, however, did not go over so well. When Senses Fail took the stage on *Conan* in 2005 to play "Rum Is for Drinking, Not for Burning," vocalist Buddy Neilsen was so anxious to be on such a big platform that he forgot the lyrics to the first verse and basically just mumbled it incoherently.

Garrett Zablocki: "None of us knew until we got home that night. We all had in-ear monitors, but in my mix, it didn't have any of Buddy's vocals. I don't think any of us did. We went backstage after we performed the song and we've got adrenaline pumping. We get home and play it and then…'What the fuck was that?' During rehearsal, he was fine. Here's the real take, audience is there, nerves probably got to him and he just blanked. At least I didn't forget my guitar parts."

Neilsen quickly recovered and remembered the rest of the song, so the rest of the performance went on just fine, but for the band (and especially for him) it was pretty devastating.

Similar things would happen with other big bands in that scene. These young guys from basements were suddenly thrust into the limelight, and, like many performers, that kind of lifestyle came with a few drawbacks, including the very stereotypical problem of addiction. Big Picture Media founder and publicist Dayna Ghiraldi recalls an incident of this kind that happened with one of her bands, The Used. It happened well after emo and screamo had reached their peak in terms of mainstream popularity but is still an intriguing example of what happens when someone from those genres clashes with the dizzying rock star lifestyle.

Thrice Owl's Cove Temple University Philly June 2002

Dayna Ghiraldi: "I remember getting The Used for *Vulnerable*. We were hanging out with Bert [McCracken] backstage, and he was not sober at that point. Then there's Quinn [Allman] who is this loving, soft-spoken flower. Then Bert comes out, and he is just a tornado. Then the next time I saw Bert, he was sober and had gone through this massive change. You got to really see who he was at the core, and he is so intellectual and so philosophical. Everything that he says is so meticulously thought through. He's poetic. [Later], I had scheduled an entire press day. Whatever it is about New York, it's like he has an allergy to it. The night before the press day, he fell off the wagon. He went on a bender. The next morning, I'm already at *Rolling Stone* or *Nylon* or somewhere, and I got a call from the manager saying, 'We have to cancel the press day. Bert hasn't come home.'

"They had to play that night, and we had a cover shoot for a magazine. It was supposed to be at six o'clock, and the photographer was there. Then it was seven o'clock. Then it was eight o'clock. The band had to take the stage at nine. It was quarter to nine when Bert got to the venue. I just remember being like, 'I need three minutes. Just sit here and take these photos.' He sat, and the photographer was amazing. All the photographer suggested was that he shift [his body] a little bit with each click, and [Bert] was just like, 'Fuck this. Fuck you.' He cursed and then went on stage.

"If I bring it up to him today, he has zero recollection of it. He'll apologize, but there's no memory of it. He'll just talk about what it was like back then to be not in control of [his] life. So many of these artists have had that taste of

what the rock star lifestyle was when things were on the rise, and that was them taking full advantage."

But while these bands enjoyed rock star status, at heart they were really as far from the definition of the word as a musician can get. Remember, these bands were singing and screaming about their feelings, not about typical rock star topics that have more to do with persona and ego and the playboy lifestyle. The giant emo bands of the 2000s were rock stars in the sense that their music was being played on the radio and their videos were being shown on TV. They were selling out stadiums, sure, but that wasn't the goal or the origin of the music. It's just that everyone was listening to it.

But that great fact soon became a great problem: everyone was listening to these bands, legally or not. When the internet was in its infancy, people were still buying physical CDs and waiting outside record stores on release day. But once people figured out that songs could not only be uploaded to websites like MySpace and PureVolume, but illegally downloaded by programs like Limewire, CD sales crashed. Emo and screamo bands began to nosedive almost as swiftly as they rose to fame.

Ryan Phillips: "It was kind of the last time that you heard guitars on the radio."

Dan Marsala: "*Page Avenue*, our first record, [is] a gold record. I have a gold record on my wall. We're one of the last bands in that scene that was ever going to have a gold record on the wall. I mean it's cool, but it's kind of meaningless now. Nobody knows what that is. 'What do you mean? Does that mean you have, like, twenty million YouTube views?' No, this is 500,000 CDs sold. The music

Thrice Owl's Cove Temple University Philly June 2002

business has changed so much in the fifteen years since then that it's not even the same model anymore. Rock music doesn't get played on the radio anymore. There's no MTV. It's a totally different world. *Steven's Untitled Rock Show*—we were on that constantly. That played a big part in breaking all of the bands in that time period in the scene. It's weird because now that's nonexistent."

Fred Mascherino: "I can't imagine another guitar record going gold again."

The other problem with mainstream culture picking up on emo music was that it put even the biggest stars of emo publicly at odds with their own genre. Gerard Way, for example, is famously quoted for saying in an interview with *Maine Campus*, "I think emo's a pile of shit." The *Rolling Stone* headline about it in 2007 actually read, "My Chemical Romance's Gerard Way Taps Another Nail Into 'Emo' Coffin."

The comment was jarring, especially for fans of My Chem who grew up loving their emo-ness. Was this all a lie? Was it hollow? If the biggest band in the genre hates it, does this actually mean nothing? My Chem didn't comment for this book, but other prominent figures in the genre have tried to interpret what exactly Way meant by his statement.

Chris Conley: "He doesn't mean that. He doesn't mean that. People can be quoted out of context in interviews they might not even remember, or they might've been in a bad mood that day. He doesn't mean that. What he was saying, probably, was in relation to the backlash that came when emo became mainstream. Even grunge had that. You listen to the third Nirvana record, *In Utero*, and

you can hear that they were almost embarrassed of their popularity and success from *Nevermind*. So that's all that is. Gerard made it mainstream. My Chem was the most successful emo band of all time. My Chem is crying while they're singing, and Gerard is the coolest and the biggest star in the history of emo. That's your pull line right there. Pull that quote out and blow it up."

Fred Mascherino: "Emo evolved past us. It's not like MTV was gonna understand. It peaked on MTV, but then MTV chews it up and spits it out and then they sign a million bands that sound like that. Just the record industry in general, that's what they do. It ruins the art. That's where it went wrong. Once it hit MTV, it starts to go down the path that glam metal went down and it's just more about the look than anything else. At that point, all the bands that are associated with it are running out of the building. I thought of emo as a burning building, and they were trying to say that they were never in it in the first place. So that's kind of where I think My Chem was coming from."

But even when bands were becoming disillusioned with their own popularity and the rock industry was bottoming out and bands' bank accounts were taking serious hits, some of them chose to reflect on it as a not entirely negative experience. For some, the death of the CD and the rise of the MP3 was not totally destructive.

Dayna Ghiraldi: "Rock music fell off the map for a minute. A lot of these artists that had major label deals did not anymore and the money wasn't there. Maybe that was the clarity they needed to get sober."

Dan Marsala: "In the time before the internet and accessibility to everything, music genres just died completely. It's kind of cool now because there's so much music that everybody kind of likes everything still. So even a band like us that maybe shouldn't still be at all relevant can still go out. Obviously, it's not as big a genre as it was fifteen years ago, but somehow it still works."

Steve Lamos: "People really didn't care for [American Football] back in the day. But the internet has made it so that that record took on a life of its own...I teach college out here—I'm not too far from Denver. I remember one kid in particular saying, 'You know, that record has like a million plays on YouTube.' I thought, 'What are you talking about?' It was truly a shock to me. We really didn't have a clear sense of what this was about until maybe a couple months before all the reunion stuff started going. There was more talk about what that record was doing and how many people seemed to appreciate it. It was a real surprise. I think even Mike was surprised."

Garrett Zablocki: "The beauty of streaming everything, I think, is that all the old stuff stays relevant."

All at once, the internet is responsible for the growth, the downfall, and the longevity of emo music. It has simultaneously been a constructive and a destructive force. The internet may be the reason that these bands couldn't keep making money and selling out stadiums the way they used to, but it is also the reason emo still manages to influence upcoming artists today.

$ 15.00 | GEN ADM STANDING | 15.00

6.25

SECTION/AISLE

GA

WWW.STARLANDBALLROOM.COM

HAWTHORNE HEIGHTS

GA 5

ROW SEAT

GA4 233

STARLAND BALLROOM

SAYREVILLE, NJ

OKJ103A

22NOV05

SAT DEC 3, 2005 6:00PM

PY0814 | GA | GA0 296 | J-TYP

EVENT CODE | SECTION/AISLE | ROW/BOX SEAT | ADMISSION

$ 30.25 | GEN ADMISSION | 30.2

7.25

SECTION/AISLE

GA

SAMSUNG & CINGULAR PRES

VANS WARPED TOUR '05

CA 46X

* * * *

ROW SEAT

GA0 29C

OLD BRIDGE RACEWAY PARK

ORJ104J

ENGLISHTOWN, NJ

12AUG05

SUN AUG 14, 2005 DRS 11A

STANDING ONLY

BRAND NEW

EVENT CENTER

BORGATA CASINO, HOTEL AND SPA

CHAPTER 10

Your New Aesthetic

Rock n' roll, punk, metal, and to an extent
hardcore, all involve posturing. Photos of bands like
Mötley Crüe, Sex Pistols, GWAR, and Terror all attempt
to portray a certain kind of image. In their live shots,
there is almost always a clear objective: sex, glam,
theatricality, toughness. Emo is one of the few rock
genres that effectively avoids this trap entirely during live
performances. Sure, there are tons of promo photos of
classic emo bands looking moody with hair in their eyes
and extra-small band tees on their backs, but during a
show these bands never put up a front.

For the most part, they were kids just enjoying
themselves. Even if they were writhing around on
the stage floor with their guitars or curled up in a ball
screaming 'til their vocal chords burst, they were doing
those things because they were moved to do so. What
comes across most vividly in these photos shot by Brian
Froustet in the late 90s and early 2000s is an unrivaled
sense of purity and free-flowing emotion. There is
movement. There is closeness. There is expression.
There is the unmistakable sense that you, the beholder,
are involved in these pictures. You're in the bedroom or
the basement they turned into a venue. You're in the
crowd wearing that Alexisonfire shirt. You're the one
with a Sunny Day Real Estate tattoo. You may even be
the guitarist wearing that Alkaline Trio shirt to rep your
boys on the road. The bassist was probably in your math
class (that is, when he wasn't on tour). Equality prevails
as there is virtually no separation between artist and fan.
There is no professionalism. There is no pretense; just the
youthful desire to connect.

Thursday Starland Ballroom Sayerville NJ 2004

Thursday Starland Ballroom Sayerville NJ 2004

Brand New Owl's Cove Temple University Philly June 2002

Brand New Owl's Cove Temple University Philly June 2002

Brand New Owl's Cove Temple University Philly June 2002

Brand New Owl's Cove Temple University Philly June 2002

Brand New Owl's Cove Temple University Philly June 2002

Brand New Owl's Cove Temple University Philly June 2002

Brand New Owl's Cove Temple University Philly June 2002

Brand New Owl's Cove Temple University Philly June 2002

Further Seems Forever Tulagi Club Boulder CO March 2002

Further Seems Forever Tulagi Club Boulder CO March 2002

Get Up Kids First Unitarian Church Philly Sept 1999

Hot Rod Circuit The Ottobar Baltimore 2001

Hot Rod Circuit The Ottobar Baltimore 2001

Hot Rod Circuit Tulagi Club Boulder March 2002

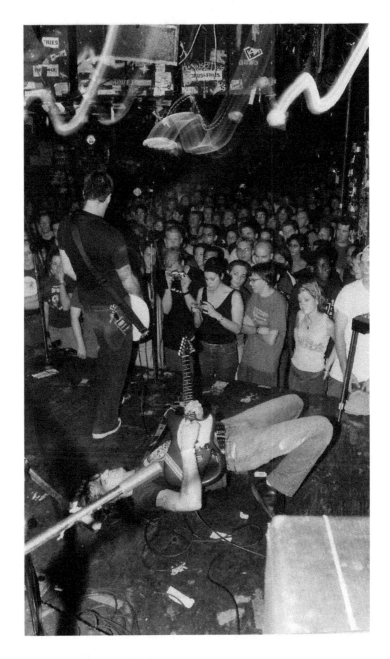

Hot Rod Circuit CBGBS NYC

Hot Rod Circuit Fireside Bowl Chicago 98 (Tattoo of Sunny Day
Real Estate's *Diary* Cover Artwork on arm)

Hot Rod Circuit Bizmos East Stroudsburg PA 98

Hot Rod Circuit Fireside Bowl Chicago 98

Hot Rod Circuit The Chukker Tuscaloosa AL 98

Hot Rod Circuit The Chukker Tuscaloosa AL 98

Hot Water Music BB Kings NYC Nov 2004

Hot Water Music BB Kings NYC Nov 2004

Hot Water Music BB Kings NYC Nov 2004

Hot Water Music BB Kings NYC Nov 2004

Hot Water Music BB Kings NYC Nov 2004

Penfold New Jersey 2000

Penfold New Jersey 2000

Penfold New Jersey 2000

Penfold New Jersey 2000

The Movielife Club Homebase Wilkes-Barre PA 2001

The Movielife Club Homebase Wilkes-Barre PA 2001

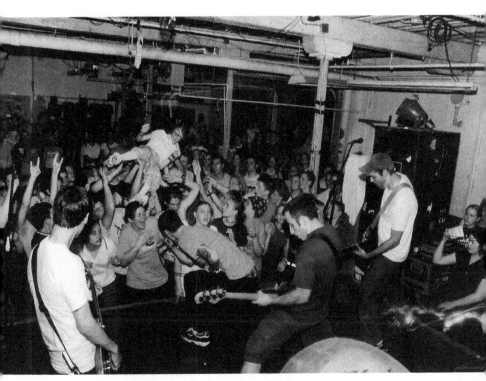

The Movielife Club Homebase Wilkes-Barre PA 2001

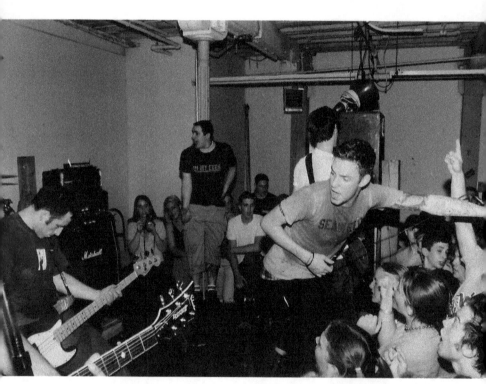

The Movielife Club Homebase Wilkes-Barre PA 2001

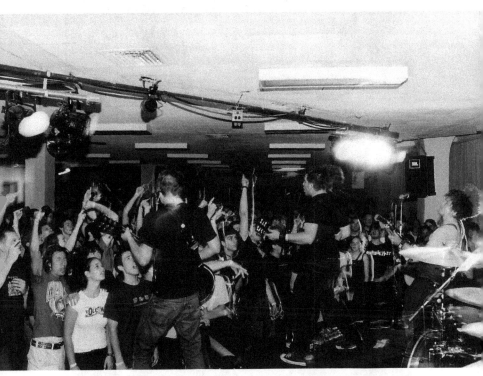

Thrice Owl's Cove Temple University Philly June 2002

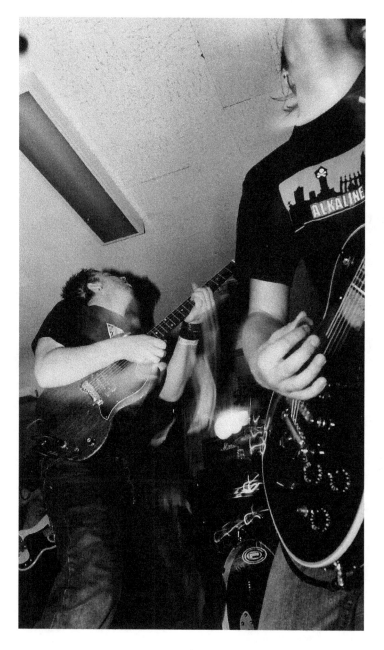

Thrice Owl's Cove Temple University Philly June 2002

There is always that moment in any genre, where, once it becomes mainstream, the original substance or soul of the musical movement gets lost in translation. Most of the bands I've interviewed surmise that the downfall of emo music (if there was one, which we'll get back to later) came as a result of the rise of emo fashion trends. It is commonly held that the rise of emo fashion weakened the gravity of the music itself and distracted listeners from the true heart of the genre. In their eyes, the further we moved into the 2000s, the greater the focus was on emo stereotypes and not on its functionality.

Shane Told: "Most of the time musicians aren't looking back. And, if they are, it's a lot of laughing at yourself, at the fashion and the haircuts. Remembering when everyone had a Sidekick that you flipped open. Everyone just kind of facepalms when they think back to those days. That's where so many people are at with it because they think of how stupid they were in their youth. People don't think about the great music that was coming out. People downplay the art and the talent and the movement we had, I think mostly because of the choice of fashion. It's kind of like the 1980s. People made fun of the 1980s so much because of the aesthetic."

Fred Mascherino: "If you Google Image emo, [the result] is not the people I think of as emo. Pink hair, crazy makeup—that sort of real gothy thing. None of the Sunny Day Real Estate type of bands [did that], they just wore frickin' T-shirts and jeans."

Eddie Reyes: "There was that age of Yellowcard and My Chemical Romance, The Used, Coheed & Cambria…there was this chunk of us that were always on tour together.

Of course later on, more bands came out of it, but I never really paid attention because it wasn't truly heartfelt. It was paper and plastic. It got Gothic. Not that there's anything wrong with that, but for some reason it just got latched onto and kids started looking that way and it got silly. Even to the real goth kids it got silly. Same thing happened to grunge—it became a fashion. It weakens it."

Shane Told: " 'Emo' was so extreme, I think. Most people were going to American Eagle or The GAP and wearing very normal shit at that time. Then the skinny jeans came out. I remember being like, 'Really? I'm supposed to wear pants that tight now?' The fashion was more what people were talking about than the music, even though the music was more important."

While there is a kind of undeniable truth to these sentiments, I don't believe that the sole role of emo fashion was to destroy the genre's sincerity and authenticity. When a sound develops into a full-blown music scene, it eventually takes on other characteristics of culture as well, which is what ultimately makes it a movement. Ideals and appearances are just a couple of the elements that go into establishing a musical moment as something more tangible and multidimensional. And, as far as music journalist and professional makeup artist Natasha Van Duser is concerned, the idea that fashion corrupted emo is, frankly, "such a cop out."

Natasha Van Duser: "I'd say [fashion] is probably one of the biggest things that turns it from just being music to an actual element of culture. You can see that especially with the 1970s punk rock movement. You can see it with 1980s hardcore. You go from the clean cut look of The Beatles to…I'm not even sure how I would describe whatever

the hell Richard Hell was wearing. The ripped-up clothes, the 'Please Kill Me' T-shirts, the safety pins through the ears. Even hardcore, where everything became almost militant. You can see these changes as statements of, 'I am associated with this movement.' "

In the 2008 documentary *Punk's Not Dead*, Shawn Stern of Youth Brigade/B.Y.O. Records expresses the same idea when reflecting on punk. "If you walked down the street and saw somebody who looked like that," he says, "it was almost instantaneous that you became friends with that person." Likewise, Mike Roche of T.S.O.L. says, "You knew right away if somebody was on your team—and it wasn't many." Both assessments apply to the emo and screamo scenes just as much as they did to punk. It's the exact same thing except with different haircuts and a generally gloomier attitude.

Natasha Van Duser: "I think there are some cliches in emo that have made it really looked down upon, retrospectively. I don't think the MySpace era or the bad bangs really helped anybody. I can wholeheartedly say that I've never had a good hairstyle thanks to this. I've had everything from the side-shave to the bad emo bangs to the five different colors badly dyed with basically fabric dye that you can't get out of your hair. It was almost like a come-join-my-club kind of call. Because you looked a certain way, you could make certain friends. It was easier to weed out who liked the same things that you did."

Aaron Gillespie: "People started dressing to the sound. I think that happens with every music culture."

Natasha Van Duser: "If you look at My Chemical Romance, especially during the *Three Cheers For Sweet*

Revenge era, Gerard Way basically set a whole tone for what emo would look like."

Fred Mascherino: "They might have had the goth look, but they were just punk."

Dan Marsala: "We were friends with My Chem and we were touring with them, but we didn't want to have that whole look and everything. We were definitely not on the fashion side of it. Obviously, I'll wear a lot of black and look like a weird goth kid half the time, but we were just more into skateboarding and punk rock and shit and we were just happy to be there. But that's every scene, whether it's hippies listening to 1970s rock or punk rock guys with huge mohawks. There's always a fashion that goes along with the music, for sure."

Just as with every musical or cultural movement that has ever existed, in rock or otherwise, there developed a way to brand oneself as part of the emo and screamo scenes. In the same way that people look to pop idols to learn how to dress and what trends are on the cutting edge of modern fashion, fans of emo music looked to the bands and what they were wearing as a visual representation of the music that they loved. From the fan perspective, fashion was a way of advertising their fondness of emo music and its values, not undercutting them. In this way, emo fashion was not a cheap mockery of the scene, but a way of showcasing one's solidarity with that community.

Shane Told: "Because of how real that is to people, then they wanna go dress like them or go to every show that they play, and they become 'an emo.' "

Natasha Van Duser: "I think there was an element of being able to separate yourself from the norm that was

very appealing, and I think that helped to further the cultural movement of emo, by not only showing you that there are other people in the world that feel like this and that have these emotions and have these drives, but also in your community that you could find. You weren't gonna go necessarily to talk to the kid with the cargo pants and the puka shells. He *might* like Sum 41, but you would so much rather chat with the dude who had pants tighter than yours and an old school AFI shirt."

It was easy for socially awkward teens who felt misunderstood to go up and talk to someone if they were wearing a Get Up Kids or Alexisonfire band tee. There was a built-in launch pad for conversation. That's how I met most of my friends and love interests over the years. It wasn't necessarily about what color hair or what kind of cut they had, but it was about the bands you could assume they listened to as indicated by those fashion trends.

Natasha Van Duser: "This is why fashion is so important. I would not have met you had you not been wearing a goddamn Motionless In White hoodie. Granted, I looked like I was straight out of a bad PacSun reject ad, but that was why I was like, 'You are going to be my friend. You don't have a choice in this matter.' I would not have done that had you looked normal. I would not have had the confidence to go up to you. But the fact that we had something in common, I was immediately comfortable enough to be social with you."

Of course, there were a ton of people who had the opposite reaction to someone wearing a black band tee, black skinny jeans, mega eyeliner, and a general look of disenchantment on their face. Not that this was anything new. (**Natasha Van Duser:** "The reason leather jackets are

still popular, I swear, is because of The Ramones. Have you ever seen The Ramones not wearing black pants and a leather jacket?") I still remember the very first day I went to school with my nails painted black. In contemporary society, you can throw a rock in any direction and find someone wearing black nail polish, but at the time it was anything but normal. I can still feel the tips of my fingers nervously curling into my palms on my school desk. I was bold enough to wear it, but was I bold enough to rock it? Was I just asking to get made fun of? In high school specifically, there were quite a few people who refused to even try to talk to me and get to know me entirely because of the way I dressed. I know this for a fact, because I had mutual friends with these people and was told that that alone was the reason they wouldn't give me a chance. So while it's true that I would have been more likely to talk to someone who looked like I did, I would *never* have flat out rejected someone because they bought their clothes from Juicy Couture or Banana Republic. Really, emo fashion trends were a way not only to find those with similar interests as you, but to identify the people who were so superficial that all they cared about was the way you looked. The standard and very short conversation between the two sides would proceed as such:

Hollister Kid: "Why do you dress like that?"

Emo Kid (a.k.a. Me): "Because I like it."

Complete and utter confusion would then follow, resulting in dead, awkward silence. And I don't think I'm far off in guessing that Hollister Kid's inner voice would then tell them, "Back away slowly and don't make any sudden

movements," because the exchange would always end in a kind of moronic, hesitant shuffle.

Why this concept was so difficult for someone to comprehend, I will never know. Why does anyone do anything? Because they enjoy doing it. I felt and still feel like myself dressed head to toe in black and studs. I would feel like a total stranger to myself if I put on a cheery, bright yellow T-shirt and completely intact blue jeans. Fashion doesn't make a person who they are, but it helps them craft an identity for themselves that they can feel comfortable in. As humans, it's very hard to accept the concept that everyone just *is*. Identities, especially in our formative teenage years, help us grapple with the more existential questions that are just out of reach, i.e. "Who am I?"

Kenny Vasoli: "If nothing else, I think it gave people identity. I know that's what it did for me. Finding music that reflects how you're feeling inside is one of the most powerful things you can find. That's what I'm searching for my entire life. I think that's the most people can ask for, is finding a community."

When I was in high school, I embarked on a serious quest to find the one item that every emo band guy had: the carabiner. You know, the hook-shaped metal thing that clips to belt loops and holds keys, lanyards, and super-exclusive stage passes? Or, for the average person, the object you snake your rope through when preparing for a mountain climb. (As far as I would imagine, these two groups don't intersect very much.) I drove from store to store trying to find the kind of carabiner that all of these musicians had. Looking back, it seems like a ridiculous and rather pointless errand, but at the time it felt like a

rite of passage. When I finally stumbled into a hardware store and found my carabiner, I donned it with pride. It was the emo equivalent of a letterman jacket—something only the inducted could wear. I had listened to all the songs. I had purchased all the CDs. I had seen the shows. I had earned this. It may seem silly now, but that accessory felt like a badge to flash to all the other kids in the scene as if to say, "Check it out. I'm legit."

Emo fashion trends also came into play in another aspect of identity-making that we've actually already talked about: gender norms. As all of these musicians have already said, the sound and the feel of emo music challenged ideas of traditional masculinity. When emo fashion trends began to develop, it was just another extension of this dynamic.

Natasha Van Duser: "I think the fact that makeup was so thoroughly embraced in emo just kind of shows how progressive the genre was to begin with. You have to remember that in the early 2000s, there was still a large wave of homophobia going around in America. I think when we use terms like 'guyliner,' it's just a subconscious moment of the homophobic nature of the time."

It's not that America is entirely stigma-free now, of course, but in certain areas of the country (especially metropolitan ones) and in the overall cultural zeitgeist, seeing men adopting a more "feminine" look is a daily occurrence. Even before that, David Bowie was androgynous and glam as fuck, and he still managed to make influential records. His aesthetic didn't weaken his music but actually enhanced it. Not to mention, he was in tight with the first generation of NYC punks, and some of those NYC punks were wearing dark makeup back then

too. So if emo ended, or at least decreased in popularity, there was more to it than the pair of jeans a person happened to be wearing at the time—especially since that pair of jeans was most likely from Hot Topic. And yes, by the way, I totally worked there once.

Hot Topic was one of the two retail chain stores that fans of emo and screamo music could visit to get their threads. Spencers, of course, was the other, but that store is more of a novelty shop/sex shop/drinking enthusiast's cave— not that that doesn't have its merits. So really, Hot Topic essentially became the "emo" brand. At least, that's how people on the outside viewed it. To kids who actually listened to bands like Jimmy Eat World or Silverstein, it was simply the only place in the mall that carried band merch. To a lot of old school punks, that concept was capitalist and just sheer blasphemy, but why wouldn't we go to Hot Topic and maybe pick up some new black jelly bracelets along the way? It was the 2000s, after all. Technology was kicking in hard and every facet of life was becoming increasingly about convenience.

Natasha Van Duser: "Where else would you go? You had to go to Hot Topic. You could go buy the same shirt and jeans combination from Abercrombie, American Eagle, Hollister—any of them—and get the goddamn same outfit. But if you wanted something that was a little edgy, a little different, you had to go to [Hot Topic]. Or make it yourself, but I'm sorry, who's got time to make it themselves these days? Have you seen how much fucking school work people have to do?"

Still, in the same way that "emo" was thought of as a bad word, so too was the mention of Hot Topic. In the mid 2000s, the two had basically become synonymous. There's

nothing objectively wrong with Hot Topic by any means, but when some idiot comes along and puts some stank on it like, "Oh, where'd you get that from, *Hot Topic*?" it feels like an insult from which you need to defend yourself. Hot Topic became a pop culture institution that had as many complexities as the music genres it was representing. For those who liked it, it was another means of bolstering their identity and their love for the bands they listened to. For those who dismissed it as weird or kitschy, it was just another piece of ammo to aim at the kid with the dyed black hair and the carabiner on his belt loop.

Natasha Van Duser: "I feel like a lot of people hating on emo just had an aversion to anything different. It was something that they didn't feel and weren't able to explain, and therefore it was bad and was made fun of."

When emo fashion trends went mainstream and became a sort of caricature of the genre, the popular definition of the word "emo" changed. But fashion didn't *really* drain emo of its meaning, because those who had soul would always have it, and those who didn't had already missed the point. The problem came when the two began to clash.

In Your Room Alone

To quote Underoath, "This might be more than a
simple conversation."[8] I'm talking, of course, about the
mental health conversation. It's a doozy. It's a hard one to
have. Despite talking about it with therapists and friends
for over a decade, I'm still not sure I'm ready to write this
down on paper for everyone to read. But I will, because
it's necessary—because emo made it necessary.

As civilization progresses, it is only natural for humans
to evolve within their own consciousness and within
society—at least, that's what I'd like to say. As far as
the actual course of human events, I believe a lot of the
progress we've collectively made in matters of mental
health and mental health awareness is due to the music
the bands in this book were coming out with at the time.
To some, this might seem like a gross exaggeration, but I
certainly don't think it is.

I think a lot of people owe the current culture of openness
to the bravery of the musicians like Senses Fail and
Taking Back Sunday and The Used who wrote about being
sad, scared, depressed, suicidal, misunderstood, insecure,
lonely, hurt, addicted, and mocked. As we've already
touched on, lyrics like that weren't really being written
before this genre came up. It was a true phenomenon for
a band to get on stage and scream and cry in their fans'
faces about how much it hurt when their dad walked
out on them or how much they just wanted to die. In
2019, the year in which I'm writing this, it's still not
fully socially acceptable to admit you have a problem or
a mental health issue. Not that every person who falls
under the umbrella of emo is mentally ill, of course.

8 "A Fault Line, a Fault of Mine" *Lost In The Sound of Separation*, Tooth & Nail
Records 2008

"I was a generally happy guy," says Kenny Vasoli, vocalist of the pop punk band The Starting Line. "I thought there was something appealing about these sad-boy kind of bands." Dayna Ghiraldi, founder of Big Picture Media, the PR company that has represented everyone from Circa Survive to The Used, reflects, "Growing up, I was very happy. I was a cheerleader, but I loved Green Day. I was supposed to be this preppy girl, but I wasn't."

Similarly, not every emo band experienced or wrote about things like depression.

Jacob Marshall says of his band MAE: "In our case, we wrote a lot about those moments of love and of friendship. There are certainly songs about the pains we went through or the moments of disappointment as well, because that's an important part of life, but we always felt that if emo was a genre that was pigeonholed into sadness, we wanted to be the other end of that spectrum. Our vulnerability and our honesty were there, but we were orienting people back to the possibilities that are inherent within life if you actually step back long enough to see the bigger picture, to see your melody in the larger symphony of life."

"To be totally open about it," says Garrett Zablocki, "I never had a problem with mental health. But once it became the forefront of the songs that kids were singing along to, it helped make it less taboo and less of a stigma. We're not the first generation to go seek a therapist; it's just no one really talked about it. If you take it out of the shadows and put it in the forefront of the conversation, it makes it less taboo and everyone kind of learns from each other and it creates more support."

Growing up a diagnosed depressed/bipolar/anxious individual, that openness and support that came from these bands was absolutely life-saving. I immediately gravitated toward the music and the artists that were going through the same things that I was. Or, if they weren't going through it themselves, at least they understood. But everybody I loved—family, love interests, friends—kept abandoning me or neglecting me. My self-worth was at an all-time low, and I felt like I couldn't talk to anyone about it. The only thing I could do was sing along to the lyrics of "Ghost Man on Third" (Taking Back Sunday) and "Pain" (Jimmy Eat World). The other teens in my affluent, happy little town seemed to me like they were feeling just fine, so I couldn't say a word. Instead, I was self-harming and sitting on my bedroom floor every night with the medication I had been stockpiling (not taking nightly as I was prescribed to do), thinking carefully about whether I wanted to end it all. Oh, the quiet things that no one ever knows...[9]

"Ghost Man On Third"

Jinx me something crazy
Thinking if it's three
Then I'm as smooth as the skin
Rolls across the small of your back
It's too bad it's not my style

If you need me
I'm out and on the parkway
Patient and waiting for headlights
Dressed in a fashion that's fitting to the

9 Brand New, *Deja Entendu*, Triple Crown Records 2003

Inconsistencies of my moods

It's times like these, where silence means everything
And no one is to know about this

It's a campaign of distraction and revisionist history

It's a shame I don't think that they'll notice
It's a shame I doubt they even care
No one is to know about this
Don't let me down

But whatever I have gettin' myself into
Maybe has been slicing inches from my waist

It's my fist vs. the bottle (and thank god you weren't
There)
And that's how bad could this hurt
Or against I won't feel a thing (and thank god you
Weren't there)
I tell you all about it
It's just not working out (to watch me hit bottom)

We were taught so much better than this
This is what living like this does

The trouble came when, despite my best efforts to hide
my self-harming, a girl in my eighth grade class made up
a story about me to one of the guidance counselors. She
(falsely) claimed that she had walked in on me cutting
myself in the girl's bathroom. That never happened, so I
can only conclude that she might have gotten a glimpse
of a scar or was just participating in the "she's emo so she
must cut herself" mentality. (By my own admission, I *was*

essentially the "emo" stereotype, which is probably the exact reason I tasked myself with chronicling the history of the genre in the first place.) Either way, I was promptly summoned to the counselor's office.

Now, I sincerely hope that this book has somehow made it into the hands of this particular school counselor, because she deserves to know that she handled the situation in the absolute worst way possible. Before she even let me speak, she looked at me as though I were a criminal. She pressed me for answers with leading questions, asking how it was that I had lost so much weight in such a short span of time, despite thinking she already knew the answer was some kind of eating disorder. She took my classmate's word as gospel and never even entertained the idea that I might be telling the truth about not hurting myself in the bathroom. I was in pain. I was in immense emotional distress and was suicidal, and, instead of receiving empathy or help, I was eviscerated. Unfortunately back then, and even still in some cases now, that's the reaction when someone finds out you're not happy like the rest.

"Pain"

I don't feel the way I've ever felt
I know
Going to smile and not get nervous
I try but it shows
Anyone can make what I have built
And better now
Anyone can find the same white pills
That take my pain away

It's a lie
A kiss with open eyes
And she's not breathing back
Anything but bother me
Nevermind, these are hurried times
I can't let it bother me

I never thought I'd walk away from you
I did
But it's a false sense of accomplishment
Everytime I quit
Anyone can see my every flaw
It isn't hard
Anyone can say they're above this all
But it takes my pain away

As if the counselor's scrutinizing interrogation of me wasn't enough of a trauma, she thought up the excellent idea of having me call my mother over speakerphone while she was at work to tell her the bad news: your daughter is a self-harming basket case, sorry. There was no attempt at a private, sympathetic conversation. This was accusation time, and this bullshit counselor decided that my mother needed to leave her job in New York City in the middle of the day to come pick me up from school, where I was no longer wanted.

So she did. My mom picked me up and drove me around for a while. We didn't discuss it. She wasn't angry like I thought she'd be. All she said was, "Where do you want to go?" And I answered, "The record store."

When we got there, we still didn't speak. She let me flip through the alt-rock section at my leisure. Senses Fail's

Still Searching had just come out, and the cover artwork of a person with dirtied hands covering all but one bulging eye behind cracked glass looked, to me, like a mirror. So I picked it up and she bought it for me, and we went home, where I played the song "Sick Or Sane (Fifty For A Twenty)" about a hundred times over. "And the white coats just don't get it/I'm a genius with a headache/ Am I a little sick or a little sane?/'Cuz I feel a little sick/ She screams…"

I was permitted to return to school the next day, unlike another girl in my class who was about to go through something similar and get exiled to a school for the emotionally troubled. (Unsurprisingly, we later became best friends.) I think it was because I was a top student; the school district prided itself on being ranked amongst the top three public schools in New Jersey, and they didn't want to lose good test scores if they could avoid it. But there was no follow up. I was never spoken to by any of my counselors or teachers again regarding the matter. None of them asked me how I was doing. None of them checked up on me or thought it was worthwhile to pursue actual counseling—go figure.

Thirteen years later, my dedication to the music that was there for me when no one else was would land me a career in the music industry. I would find myself sitting with Senses Fail founder, guitarist, and main songwriter Garrett Zablocki at The Bean, a coffee shop in Manhattan on 12th and Broadway. I would make the decision to tell him this same story, and he would respond:

"That record in particular, all Buddy's talking about is taking pills. If you were going through that stuff, that was definitely a good record to listen to because when we

were writing that, he was so pilled out on whatever his antidepressants were that he was talking to the drywall. Writing that record, when he finally came out of it to get pen to paper, he'd actually write about this stuff. I would imagine it makes you feel like you're not alone."

I would feel my heart swell. It would hurt, but it would be a good type of pain. A pain acknowledged by the very musician who had (although at the time unknowingly) helped me carry on with life when I didn't want to. It would be the very embodiment of the phrases "coming full circle," "turning the page," and "closing a chapter."

"Yes," I would say to him in the end. "It does."

The success of emo wasn't about insane record sales or chart-toppers, although it did have both of those things. Emo was successful because it touched so many people, deeply and sincerely. What a strange power it had—and still has—to heal. I know I am by no stretch of the imagination alone in remembering nights when my panicked breathing was calmed by Jimmy's "For Me This Is Heaven," or when, shaking, I was consoled by The Used's "Blue and Yellow." And I know, unfortunately, that I wasn't the only one who needed those things. I wasn't the only one putting myself in physical danger in an attempt to try to numb my emotional pain.

"To Write Love on Her Arms."
A story by Jamie Tworkowski

Pedro the Lion is loud in the speakers, and the city waits just outside our open windows. She sits and sings, legs crossed in the passenger seat, her pretty voice hiding in the volume. Music is a safe place, and Pedro is her favorite. It hits me that she won't see this skyline for several weeks, and we will be without her. I lean forward, knowing this will be written, and I ask what she'd say if her story had an audience. She smiles. "Tell them to look up. Tell them to remember the stars."

I would rather write her a song, because songs don't wait to resolve and because songs mean so much to her. Stories wait for endings, but songs are brave things bold enough to sing when all they know is darkness...

...She has known such great pain; haunted dreams as a child, the near-constant presence of evil ever since. She has felt the touch of awful naked men, battled depression and addiction, and attempted suicide. Her arms remember razor blades, fifty scars that speak of self-inflicted wounds. Six hours after I meet her, she is feeling trapped, two groups of "friends" offering opposite ideas. Everyone is asleep. The sun is rising. She drinks long from a bottle of liquor, takes a razor blade from the table and locks herself in the bathroom. She cuts herself, using the blade to write "FUCK UP" large across her left forearm.

"Emo music," Jamie Tworkowski, founder of the mental health organization of To Write Love On Her Arms[10] starts, "maybe like all good music, was and even is allowed to be honest. People fall in love with these bands and these songs because they feel true, because that lyric expresses how [they] feel and maybe it's something [they've] never known how to say or how to express. Our hope was that these wouldn't just be things we could sing along to at a concert or when we listened to these songs, but these could be things we could also express in our everyday lives that we could talk about over coffee or a meal with a loved one. And, more than anything, that if someone needed help, they could be honest and take that step."

My first honest step came not too long after my incident at school. The adults all stopped talking about it and didn't do anything to help me, so my self-harming habits continued and intensified. At one point, between starving myself due to poor self-image and cutting myself, I actually decreased my white blood cell count to the point where my immune system started to crash. I had a fever and chills for days. It was hell, and I had done it to myself.

Eventually I recovered, but not long after that I almost caused myself to bleed out entirely. It was kind of an accident, because my friend and I had been drinking. As it often happens when one gets too drunk, I quickly began to descend into my darkest, most raw emotions. My friend tried to talk me down, but I had had enough. I scrambled down the stairs from my room and into the kitchen, where I grabbed the biggest knife I could find. My friend didn't get there fast enough to stop me. (If you happen to

10 If you or someone you know is suffering from a mental health issue, To Write Love On Her Arms can point you to both local and national help centers. Visit twloha.com for more information.

be reading this, I'd like to say I'm sorry, because I know now I hurt you, too.) I slashed through the center of my left forearm, not realizing the actual depth of the wound.

It kept bleeding. No matter how many paper towels I used, it just kept bleeding. Feeling literally and figuratively drained, I passed out at around three in the morning. As I slid into unconsciousness, I didn't know if I'd be waking up again. I didn't go into a black sleep like I would on a normal (a term used very, very loosely) night. I went into static. That's what I saw and felt—just white noise. To my surprise, I woke up at around seven o'clock sober, and I realized the extent of what I had done and became scared of and for myself.

I couldn't breathe that day. Taking deep breaths hurt too much, and taking shallow breaths didn't give me enough air. There was nothing wrong with my lungs, but the severity of my panic and trauma made my chest hurt in the way that it does after a first-love heartbreak. That was the moment that made me finally seek professional help again.

Previously, I had given up on psychiatrists and therapists because none of them actually empathized with me— they just analyzed and prescribed. I didn't feel connected to any of them, and none of them understood the way I felt no matter how much they nodded in comprehension.

"I don't think I had any language as a teenager for what depression is or what self-injury is," Tworkowski continues. "Self-injury to this day would probably be the least understood of all the issues that we talk about. There's a lot of shame, and a lot of people don't even have a place to start in terms of understanding why someone

would do that or what it's about. So many people focus on the act of self-harm and not the idea that it's someone using pain to cope with pain."

No matter how much I tried to explain it to doctors or friends that were willing to listen, no one ever fully understood what I was saying and why I did the things I did to myself. Most people have the built-in instinct for self-preservation and would never consider causing themselves injury, but when emotional pain gets so bad and one's sense of worthlessness becomes so great, that instinct all but disappears. "I'm already hurt," the mind says. "What does it matter if I'm physically hurt, too? I guess I deserve it, anyway. That has to be why this person left me. That has to be why this person doesn't care. I can hurt myself and hurt myself and no one will care."

But while it was a form of self-punishment, it was also a form of self-comfort. I could channel my emotional pain into physical pain and focus on that instead. Then, after I felt that pain, after I made that wound, I could start to clean and patch myself up again. I could give myself the care that I needed.

But, as I said, people didn't understand that. Actually, what happened more often than understanding was ridicule. "People only cut themselves for attention," they'd say, making the pain feel even more invalid and the self more worthless.

"The best thing I ever heard said in response to that," Tworkowski says, "was from a friend who's a licensed mental health counselor. He said, 'If someone is hurting themselves for attention, then they certainly deserve our attention.' I thought that was really powerful. I thought

that was a way to take that assessment that is so common and turn it on its head. Oftentimes it's not about attention, it's about desperation. It's about struggle. It's about this deep pain. It's about depression. Nothing helpful comes of dismissing it as [a need for] attention, but I also loved what my buddy said about it. Let's get them the help that they need. It always felt important to zoom out and focus on the whole person and that this is a person who is hurting and this is a person who needs help."

When I did reach out for help, I was finally able to grasp onto a hand. When I made this particular call, I finally lucked out. I happened to find a therapist who vibrated on my wavelength. He felt *with* me, not just *for* me. I would continue to see him for the next ten years, and during every one of those years, he changed my life for the better. I would not be the person I am today without him. Aside from the bands written about in this book, no one else has made such an immeasurable impact on my life as he has. Emo music taught me I didn't have to be alone in the dark, and my therapist taught me to turn on the light.

Why do I tell you this story? Why do I go into such terrible detail? I can tell you that it's not for attention—not for me, anyway. It's because there are people out there like me who are still misunderstood and judged for doing the same thing. It's still taboo to talk about. But before bands like Thursday and Senses Fail and The Used came along, it was even more taboo. Not that they all talked about hurting themselves, but they did talk about those same emotions, openly and honestly. And I truly believe that it's because of those bands and other emo acts that we have our current culture of openness toward mental health. People were finally singing about it, so people were finally

talking about it. And I can tell you the exact moment and lyric that really blew the topic open in popular culture, and you probably already know it:

"I'm Not Okay."

—My Chemical Romance,
Three Cheers For Sweet Revenge (2004)

For all the controversy that surrounds the band regarding whether they were actually emo or not, this point is not up for debate. Other emo bands had said it before they did, but the moment "I'm Not Okay (I Promise)" became a radio sensation was the moment the world stopped and realized that that was an acceptable statement to say out loud.

"I do think that people are more and more open and more and more aware," Tworkowski says. "In almost any circle that you run in—mental health, suicide, addiction—I think we see more and more of these stories. And I would like to believe that in some small way, because of that, the stigma begins to lessen. We really believe that as people talk about it, it makes it easier for other people to talk about it. The mental health conversation affects people who look different, people of different ages, people who vote differently—it transcends every way that we try to classify or organize people."

This is not to canonize everyone who was ever in an emo band. They were not all saints; they were and are human. But that's exactly why they mattered. That's exactly why they made a difference. These songs were humanizing, plain-spoken, and poetic. They were written by people you could reach out to, not by untouchables like the sex

and fame-obsessed Mötley Crüe or KISS. These songs were and are real.

Now, there are numerous other organizations similar to To Write Love On Her Arms that work with the music industry to promote awareness of and assistance with mental health issues. Some such organizations include Hope for the Day, A Voice for the Innocent, and Can You Hear Me?, all of whom have partnered with and helped sponsor the Vans Warped Tour and stem from the concept of opening up about personal problems through art and music.

$ 15.00 GEN ADM STANDING 15.0

6.25 WWW.STARLANDBALLROOM.COM
SECTION/AISLE
GA HAWTHORNE HEIGHTS

GA 5
ROW SEAT
GA+ 233 STARLAND BALLROOM

OKJ103 SAYREVILLE, NJ

22NOV05 SAT DEC 3, 2005 6:00PM

PV0814 GA GA0 296 J-TYP
EVENT CODE SECTION/AISLE ROW/BOX SEAT ADMISSION

$ 30.25 GEN ADMISSION 30.2

7.25 SAMSUNG & CINGULAR PRES
SECTION/AISLE
GA VANS WARPED TOUR '05

CA 46 * * * *
ROW SEAT
GA0 29 OLD BRIDGE RACEWAY PARK

ORJ104 ENGLISHTOWN, NJ

12AUG05 SUN AUG 14, 2005 DRS 11A

STANDING ONLY

BRAND NEW

EVENT CENTER

BORGATA CASINO, HOTEL AND SPA

Did Emo Die?

As long as we're spending time talking about
what did or did not kill emo or discussing what emo music
left behind, we should probably ask the question, "Did
emo actually die?"

When we think of a pop cultural phenomenon dying, that
typically implies that it disappeared from the spotlight of
mainstream media. But, if that were the indicator of emo's
demise, then we'd find ourselves in a conundrum where
a genre that never aimed to break into mainstream fame
(and resented it, even) ended up having its fate decided by
just that.

Fred Mascherino: "Not one of those basement band kids
would have chosen to do that. They all thought they were
breaking the rules and creating something new, and they
never would have said, 'I wanna write a hit that I can play
until I'm fifty.' They would've thought that was lame."

Kenny Vasoli: "When I started to back away from it in
2007, it started striking me as this very costumey thing. It
imploded in on itself where I wasn't seeing the basement
of it anymore. I was seeing a lot of copycats and trend-
hopping. I think it was a confusing time in '07/'08 where
they had to still sell tickets to these punk festivals, but
they didn't quite know how to keep a DIY edge to it."

"This ain't a scene, it's a goddamn arms race."

—Fall Out Boy

Tom Mullen: "In 2004, I started working at Equal Vision
Records in Albany, New York, right at the height of a few
bands on the label like Circa Survive, The Fall of Troy,
Chiodos, and Armor for Sleep. The label was firing on all

cylinders, and we were breaking bands on Warped Tour and getting their videos on MTV and Fuse TV. Then, as many bands have mentioned on my podcast since, it started to be a copy of a copy. By 2007, I was frustrated with how it was being misunderstood and started [the] *Washed Up Emo* [podcast] as a way for people to find bands that weren't being talked about anymore online at all."

Eddie Reyes: "You have the commercial bands that are put together by labels that kind of weaseled their way into our scene and ruined it. Probably around 2008. It had no soul, it had no meaning. They didn't grow up playing in basements. They didn't play backyards, they didn't play in VFW halls. A lot of those bands, it was all handed to them."

Fred Mascherino: "It basically gets ruined when everyone's trying to do the same thing. And then all of a sudden you're at Warped Tour and you're looking around and it's Blood On The Dance Floor and you're like, 'OK it's officially over.' The exact moment that I think emo died was the day MySpace ended. When everyone went to Facebook and stopped using MySpace. It didn't break ground ever again on another platform. Now I start over on Spotify. I'm at peace with it. I recently actually talked to Adam for the first time in over ten years. Basically, I left the band because I missed the way it felt to be in a band. There were so many people making it into a business. I don't feel that I really was fighting with the band members. I feel that we were mutually unhappy. I felt like we were being pushed in directions that were more money-related rather than artistic. It wasn't what I got into music for, so I figured I would bow out. I actually

wrote down a date in my phone and I said, 'If I'm still unhappy on this date in one year, I'm done.' And that's what happened."

Feeling as though I belonged to the emo scene growing up, I definitely did feel like it all disappeared by the time 2010 came around. Computers had taken over, and it was no longer cool to play real instruments or sing about subjects that actually mattered anymore. Hell, From First to Last vocalist Sonny Moore turned into the EDM DJ phenomenon Skrillex. Pop music became completely focused on digital sounds that could be played in clubs, and with that there also came an infatuation with hip-hop and rap. It seemed to me as though emo and screamo had been forsaken almost overnight. One day I looked around and suddenly didn't recognize anyone. But during the process of interviewing emo artists and influencers for this book, I found that not everyone feels like it's completely over.

Dan Marsala: "All music evolves and changes with the time. I'm surprised that all of the bands from that time can still go out and successfully play shows. You couldn't go play for fifteen people if you were Poison in 1993 because Nirvana was the coolest band. In the time before the internet and accessibility to everything, music genres just died completely."

Ryan Phillips: "By my estimation, it seems like it all kind of went away, and then in the last couple years you've seen Emo Nights all across the country. I think it's kind of come back in a way. I'm so proud of whatever small legacy we'll leave or any kind of contribution we've had to any kind of cultural movements or scenes. At the risk of

sounding arrogant, I think we played our own little part of that, and that's fucking cool, man."

Babs Szabo: "I honestly never know how to comment on anybody saying that there has been a revival, because I don't remember a single day of my life where this music wasn't a part of it."

T.J. Petracca: "Maybe in the cultural zeitgeist, it had a moment where it wasn't cool, but I don't think this genre or this community really went anywhere."

Tom Mullen: "There's something to be said about music that can survive being such a negative term to many, and still, it survives. That's pretty punk rock to me."

Garrett Zablocki: "It was the greatest way for me to grow up. I'm sure other people would agree, but I'm not gonna speak for anybody else. [It was] by quitting high school sports and sitting in my room and practicing guitar and really diving into the music that I was listening to and trying to develop my own sound, just because I thought there was something I wanted to hear that didn't exist. I love the fact that that turned into a profession for a really long time and that I didn't have to make a compromise with myself. The timing of the band and the success was perfect for me. It was the best way to grow up. It's like drinking from a firehose in terms of real life. Seventeen, eighteen years old with no money in your pocket and no business experience. Learning all that shit real fast and just having the freedom of developing as an adult while doing something that's not really the norm, and doing something that was just my thing. Whatever it is, from your head to paper to fruition, I can only wish that upon everybody."

Chris Conley: "It's like saying punk rock could ever die. Punk rock will never die. Rock 'n' roll will never die. Emo will never die."

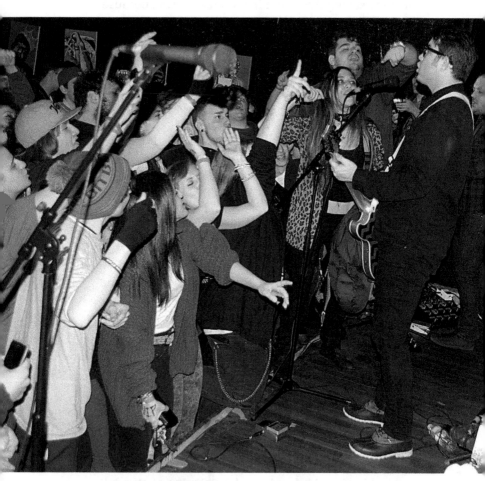

Hawthorne Heights Hashtag Bar Staten Island NY March 2015

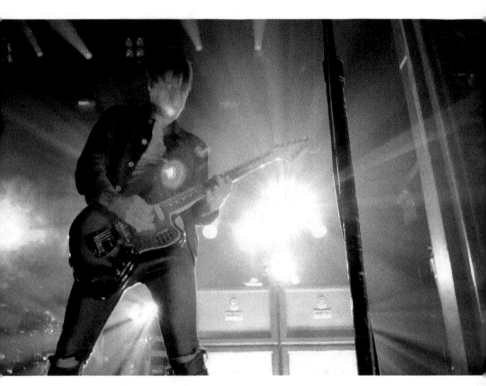

Silverstein Webster Hall NYC December 2015

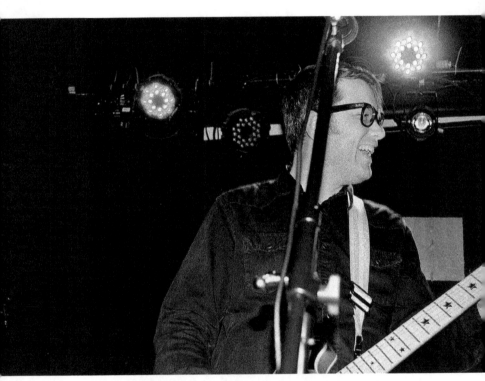

Hawthorne Heights Hashtag Bar Staten Island NY March 2015

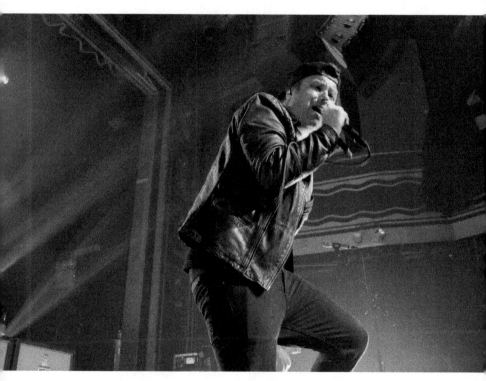

Silverstein Webster Hall NYC December 2015

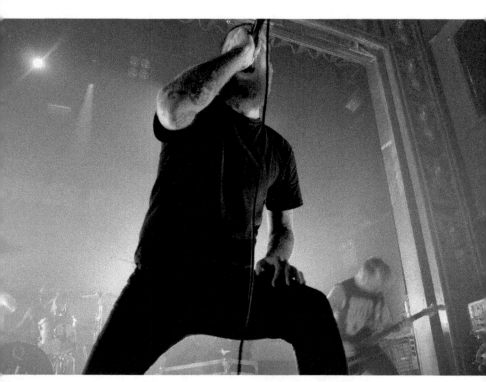

Senses Fail Webster Hall NYC December 2015

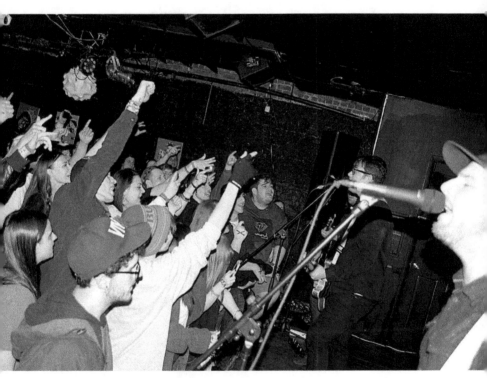

Hawthorne Heights Hashtag Bar Staten Island NY March 2015

$ 15.00 GEN ADM STANDING 15.00
6.25 WWW.STARLANDBALLROOM.COM
SECTION/AISLE
GA HAWTHORNE HEIGHTS
GA 5X *
ROW SEAT
GA+ 233 STARLAND BALLROOM
OKJ1036 SAYREVILLE, NJ
29NOV05 SAT DEC 3, 2005 6:00PM

PV0814 GA GA0 296 J-TVP
EVENT CODE SECTION/AISLE ROW/BOX SEAT ADMISSION

$ 30.25 GEN ADMISSION 30.2
7.25 SAMSUNG & CINGULAR PRES
SECTION/AISLE
GA VANS WARPED TOUR '05
CA 46X * * * *
ROW SEAT
GA0 290 OLD BRIDGE RACEWAY PARK
ORJ104J ENGLISHTOWN, NJ
12AUG05 SUN AUG 14, 2005 DRS 11A

STANDING ONLY

BRAND NEW

EVENT CENTER
BORGATA CASINO, HOTEL AND SPA

CHAPTER 13

Representations of Emo in 2010s Pop Culture

Pop music in 2019 still hinges upon EDM, hip-hop, and rap music, but as others have said, emo has not been entirely forgotten. In fact, emo and screamo have proved to be major influences for a new generation of rappers who blend that moody sound with the swaggering rap style. It's called SoundCloud rap, so named because of the digital platform SoundCloud where these artists upload their songs. In the same way that emo artists were sitting in their rooms by themselves writing songs they would eventually play in the basement down the street, SoundCloud rappers sit at home with their computers and recording software and upload their emotional songs directly to the SoundCloud community. Some admire the new take on the genre, while others doubt its authenticity.

"Life Is Beautiful"
by Lil Peep

And if you ever need a friend then you got me
And in the end, when I die, would you watch me?
And if I try suicide, would you stop me?
Would you help me get a grip or would you drop
Me?
Run away, make friends with the moon
Why you trippin'? You'll be with your friends soon
There comes a time, everybody meets the same fate
I think I'mma die alone inside my room

Ethan Fixell: "We're seeing it today in Soundcloud hip-hop, for example. It is an incredibly influential movement that encouraged artists to write with their hearts on their sleeves."

Garrett Zablocki: "There was a trend before us and there was a trend after us, and now you have mumble rappers and SoundCloud rappers. And, if you listen to a lot of their songs, they sound like our songs but just rap. If you look at their influences, they're our bands. Lil Peep, Juice WRLD—it splinters off and morphs into something different."

Natasha Van Duser: "One of the issues with contemporary emo revival hip-hop is I feel like people are sad for superficial reasons. With original emo, there was a real sense of depression, anxiety, and suicidal tendencies (no pun intended) within the emo community and the lyrics behind it gave it a real backbone. Not to diminish what these [songwriters] feel, but I just don't necessarily believe the depth of sadness that they have through the way that they convey their music, and I think that's the jarring moment for me. If anything, Lil Peep…I think is more of that Sid Vicious complex where you practice what you preach, and not in a good way. But a lot of them, I feel it's almost that they have taken the image to the extreme and just kind of filled in the words to go with it."

T.J. Petracca: "Post Malone, a lot of his lyrical content and his influence is from the emo world. You have Halsey and The Chainsmokers singing about blink-182. Artists now breaking like Juice WRLD where the lyrics could definitely be a Silverstein song. You hear it all the time."

"Lucid Dreams"
by Juice WRLD

You left me falling and landing inside my grave
I know that you want me dead

I take prescriptions to make me feel a-okay
I know it's all in my head

More traditional-sounding emo bands—bands featuring actual instruments and punk-oriented vocals—are in existence today too, although they are not as popular. Some of Kenny Vasoli's favorites, for example, include Thin Lips, Hop Along, Slaughter Beach Dog, Hurry, Weather Box, Sidekicks, Pup, Retirement Party, and Jeff Rosenstock. So it could be said that emo bands didn't ever die off, they just went back where they came from: underground.

Eddie Reyes: "I kind of feel like it's being brought back to life. I'm starting to notice it."

Matt Pryor: "I hear younger bands now that I think sound like they could have been our contemporaries twenty years ago, and I find that enormously pleasing. Tiger's Jaw is fucking awesome. We just played with them in the UK. [They're] younger than me, but I feel like I've known [them] for fifteen years."

Chris Conley: "I am blown away by these younger bands coming up, like Touche Amore and Joyce Manor. Watching Touche Amore overseas, I thought to myself, 'This is one of the best bands in the entire world.' "

Tom Mullen: "I'm learning from those younger than me. What's happening today, what is the next wave of bands from the genre that are coming up and how do they sound? To know that there is still that flame from the next generation on this word and genre gives me hope."

Dayna Ghiraldi: "I had been banging down *Rolling Stone* and *Nylon* and all these mainstream publications' doors

for years. It was just, 'Pass. Pass. Pass.' Then, all of a sudden, they want to cover these artists now. I really do think that it was [because of] the way that us scene kids would stick together back in the day. These kids had grown up and gotten jobs at these credible places, and they were trying to bring back something that they loved. So I was able to find those people at these publications that loved this type of music. All of these people are back in this movement again where they're feeling this nostalgia, and they want to cover it now at these places that never gave two shits before."

Nostalgia is the other, if not the main market that emo and screamo occupy now. Nostalgia was the driving force behind the event many claim to be behind the success of the so-called emo revival happening today: Emo Nite. (Although, the creators of the now national, touring event don't consider it nostalgia because they never forgot about emo in the first place.)

Babs Szabo: "We started it in 2014. T.J. and I met at a friend's birthday party, and we sang Dashboard Confessional "Hands Down" karaoke together. That's what sparked the idea: our love for that song and our love for this music. We realized there were not really any bars in LA that played pop punk or emo songs."

T.J. Petracca: "I think about this a lot. I think everybody's kind of just searching and trying to connect with other people all the time. Emo Nite offers a place for people to do that. Babs and I became friends because we liked the same music, and so many other people are like that too with this genre. I don't know what it is. At the same time, it is a fun night out to go and have a few too many beers."

Babs Szabo: "We've also had a lot of DJs outside of the genre that grew up listening to this music, but maybe they make pop songs now or hip-hop songs."

T.J. Petracca: "When we started Emo Nite, we started selling shirts that say "Sad As Fuck" as a joke, and there have been critics of that shirt saying that we glorified depression. But then you look at photos from our event or photos from any emo concert and see the smiles on peoples' faces while they're wearing the shirt "Sad As Fuck.""

Kenny Vasoli: "It's strange that it had its place of origin from the really humble beginnings of this VFW, playing in barns, playing in basements kind of thing and it's grown into this celebrated era where there are DJ nights that are like a thriving business. Emo Nites are basically like corporations at this point. It's really wild, and I didn't see it coming."

Shane Told: "Don't get me wrong, the Emo Nite movement has been really cool and great for re-sparking interest in this scene that existed. It's been really great for me and my career now. I will say, though, that most of the bands they play aren't really emo bands. It's more of a pop punk thing. The best example of that, I would say, is blink-182. I don't consider blink-182 an emo band in the least."

Fred Mascherino: "I was asked to DJ an Emo Nite recently. So I put together my playlist and I've got At the Drive-In and Jimmy Eat World—but not "The Middle," the old *Static Prevails*. Those late 1990s bands—Texas Is The Reason—those bands are what we thought of as emo. So I put all of those on my playlist and I sent it to the

head DJ of Emo Nite and he goes, 'Oooh, you've got some pretty deep cuts here...' At a typical Emo Nite, you'll hear Linkin Park, you'll hear Evanescence, and that's just not basements."

Tom Mullen: "By early 2011, I was living in NYC and a friend owned a bar that was into punk/metal. One text chain led us to starting the first Emo Night in NYC, and we've been hosting a night in the NYC area every month since then, just celebrating our eighth year. Those [Emo Nites] since 2014 took off as a more 2000s pop night due to the adjacent bands from those eras getting on Top 40 radio. The difference with ours is [we play] every era from the '80s through today and not what was just on the radio or popular."

Kenny Vasoli: "I want youth culture to be able to do whatever it does. It was different when I was doing it, and it has the right to be different whenever whoever is young is doing it. It's up to them; it's not up to me. I think it's a little foolish to say it should always stay the same."

Emo and screamo have bled into other areas of pop culture as well, including TV Shows (not MTV), podcasts, and even films. Half of the pop culture material out there about emo is actually legitimate, while the other half is comedic and satirical. And, everyone knows, no one does satire better than the creators of *South Park*, Matt Stone and Trey Parker.

In typical *South Park* fashion, the episode "Goth Kids 3: Dawn of the Posers" is both unforgiving and hilarious, at times vicious and at others delightfully spot on. The storyline for this episode (spoiler alert) follows one of South Park's goth kids as she gets sent away to a reform

camp for her attitude and comes back emo. Instead of
bitching angrily at her mother and sitting in candlelight
listening to The Cure, little Henrietta now cuts herself,
listens to Sunny Day Real Estate, and has "My Chemical
Relationship" and "Zaozin" posters on the walls of her
room. The other goth kids try desperately to get her to
return to who she was but not without having confusing
debates amongst themselves as to what the difference is
between goths and emos. Edgar Allan Poe is summoned to
help deal with this crisis, but he just calls everyone a poser
and doesn't do much else. In a *deus ex machina* ending,
this whole emo-brainwashing experiment ends up being
part of a reality TV show. The point (I think?) is that emo
was just another ridiculous fad that told people to act and
think in certain ways. Of course I don't agree with that,
but it is still one of my favorite episodes of *South Park*.

According to ex-Taking Back Sunday guitarist Fred
Mascherino, that wasn't the only prime time opportunity
that the genre got, either.

Fred Mascherino: "We were watching this episode of
Cops, and this girl was getting put into a cop car. She
turned to the camera and went, 'I just wanna break you
down so badly.'[11] She was on meth. I'm sure if any of our
early fans saw that they'd be like, 'See! That's why I don't
listen to them anymore!' "

Emo culture was also the subject of an Australian
bildungsroman flick entitled *Emo the Musical*, which came
out via Matthewswood Productions in 2016. But these film
and TV spots would fall under the category of comedy or
satirical criticism. Where emo remains relevant and real
is not in visual media, but in podcasts such as *Washed Up*

11 "MakeDamnSure," *Louder Now*, Warner Bros. 2006

Emo, Lead Singer Syndrome, BadChristian, 100 Words or Less, and *Going Off Track.* Podcasts like these are hosted by and feature key figures from the emo scene, from band members of Silverstein and Emery to Steven Smith and *Alternative Press*'s Jonah Bayer.

But it isn't just nostalgia or retrospectives that keep emo alive; it's that confusing, made-up thing we talked about called "identity." An identity is something you create. It's a portrait you paint that you feel represents your soul most accurately. We define ourselves by the books we read, the photos we take, and the music that we listen to. Emo is very much alive within my identity; I consider it a part of who I am. But it's not just a hobby or an interest. It is as much a core fiber of my being as are my heart and my thoughts. For some, it is as much a part of their identity as their gender or sexual orientation. Within these songs are my best and worst memories and my best and worst self. Within me is a desire to keep reminding the world how important emo was and is. Because no, it wasn't just a phase or a passing fad. It wasn't that music you listened to when you were thirteen and then gave up on when you became a "real adult." Emo is credible. It is valuable. It is irreplaceable, and my friends and I—everyone in this book—want the world to recognize that.

Tom Mullen: "There's a duty in my life to make sure [emo] is preserved and saved for future generations. Just because the photo or the song is on your phone doesn't make it last forever. We have to save what's happening now, save what this genre is and be able to document and archive properly. That will be my last dying breath. 'Hey, don't forget to save that flyer, the band may want to share that later…' CROAK."

Right there with you, Tom. Right there with you.

CHAPTER 14

With the Cellar Door Wide Open

This book wouldn't be anything without the fans who supported and continue to support the bands within these pages. This history is as much yours as it is theirs, which is why I am lucky to have received some of your personal stories to share with the world. Thank you.

Fan Comments

Honestly, I don't really equate it to sadness and loneliness like most people do. I see it as more of a statement of the human condition. Also, I see emo almost as a state of mind, just like being punk or whatever someone may define them self as. It's almost created an entire life perspective for me. Most people view emo as a phase in someone's life or equate it to being young, but I don't see it that way either. At this point, I'm thirty-seven. It will probably have an impact on me for the rest of my existence.

—Alan Naso, 37, Pennsylvania

I moved when I was nine to a new state, and the emo kids at my new school were the ones who welcomed me and made me feel like I belonged. The music reminded me that I wasn't the only one feeling angry, frustrated, and lonely, and it met me where I was. I still listen to it consistently to work through feelings or get me pumped up. Vampirefreaks.com 4 lyfe.

—Leah Casselman, 26, California

It was a time stamp in my life when I was finding myself and my emotions. Hawthorne Heights and Alkaline Trio—

so many others. I felt every part of the music and lyrics for the life I was living at the time.

—Justin Graceffo, 33, New Jersey

Emo was punk rock that you could listen to when you were having the absolute worst day or best day of your life…which was basically every single day as a teenager and early twenty-something.

—Randolph Schulz, 33, Michigan

Listening to *From Under the Cork Tree* for the first time at fourteen and feeling like someone got how it felt to feel like you didn't know anything, while everyone else had the answers and you didn't. Feeling seen in a way that mainstream music didn't see me, and (specifically as an asexual person who didn't realize that 'til way later) feeling seen by the confusion and helplessness voiced in [the] music instead of just straight desire. I didn't discover MCR until I was twenty-two, but even then having that unapologetically angry/helpless/sad outlet was key to surviving a really rough retail job. *The Black Parade* is now a key component of the YA novel I'm working on, which is an adaptation of *Hamlet* set in 2007 and heavily focused on the emo subculture.

—Hannah Lamarre, 25, Massachusetts

Emo to me meant finding a community full of people willing to embrace all the feelings and emotions that life brings, crying and singing and screaming at the top of our lungs. The Used was and always will be the epitome of emo to me. The Used shows = our church. Praise be.

—Amber Minton, 33, Oklahoma

Emo saved my life. The Used put every feeling I ever had and every feeling I thought I was alone into words and music in a way no other band ever had before. Their music, and emo music more broadly, was melodic and unafraid to embrace both frustration and anguish—even if that made the genre a huge target for homophobia from the punk & metal scenes. To echo Amber, emo also meant community for so many of us who felt like we didn't fit in to any other subculture. Being a Used fan for the past fourteen years has allowed me to form strong friendships with people from all over the world who feel as deeply and spiritually connected to their music as I do. Emo also provided a sense of community for those of us who are LGBTQ. When I was a young and closeted lesbian, it introduced me to musicians like Bert McCracken and Gerard Way who defied gender norms and stereotypes, told us it was okay to be gay at a time very different from today, and did tremendously valuable charity work with LGBTQ organizations. Could go on forever, but I'll wrap it up there! Thank you for writing this book!!

—Star, 26, Pennsylvania

What made emo special was the honesty of the lyrics and the unconventional song structures. It was different. It demanded a reaction. For me, the lyrics taught me more about life than any classroom. The lyrics dealt with real life experiences. What emo showed me was that it was okay not to be okay, that there were others that felt the same way as I did. The genre was initially met with mixed reactions because the general music listener wasn't ready for it. People chose not to understand it. Times have since changed and the genre is vastly more accepted. It's

beautiful to see many of the first wave of emo bands get the credit they deserve. The community of the genre went hand in hand with the music. There's nothing quite like going to a show where everyone shares similar thoughts, emotions, and experiences. Openness, acceptance, and inclusion are what come to mind when thinking of the emo community.

—Ryan Bertone, 29, New Jersey

As an awkward & artsy bisexual girl growing up in the Deep South who comes from a family where image is everything, emo/screamo music was one of the first things that I got to choose as part of my identity. Struggling with mental health issues my whole life, the music of bands like The Used, My Chemical Romance, Escape the Fate, Chiodos, and so many more gave me something to scream back at a world where I felt so desperately lonely. It made me who I am today, a twenty-five-year-old queer law student made up of unicorns, black clothes, and anime quotes. But, most importantly, it gave me the knowledge that everything might suck, but it will always get better because I'm not the only one who feels that way, nor will I be the last. Emo music saved my life more than once, and I can't imagine life without it.

—Kat Westbrook, 25, South Carolina

Emo to me was about finally finding a place where I fit in! I was always so different from everyone else...until I found "EMO." Not just the music but the scene...people who not only dressed and listened to the same music as I did but FELT the way that I FELT!

—Lee Jennings, 29, Georgia

I remember first discovering more mainstream emo bands like My Chemical Romance and Fall Out Boy before eventually delving into Taking Back Sunday, Thursday, Armor For Sleep. It all had such a cool vibe to it and was so relatable for a broody teenage like myself. It will always have a special place in my heart!

—Imran Xhelili, 25, Long Island

My first concert ever was the Taste Of Chaos tour, which really inspired me and made me want to write and perform music for a living. Even as my band grows and evolves, I will always carry a torch for emo because it was the music that started it all the way back when.

—Vincent Torres, 31, Delaware

Acknowledgements

Everyone who was gracious enough to let me interview them for this book

PR and management who helped arrange interviews

Every band mentioned and not mentioned that played a role in this scene

Every journalist, photographer, and industry head who helped make this scene what it was

Every editor I've ever had

Noubar Markarian
Nancy Markarian
Judith Markarian
Ryan Bertone
Natasha Van Duser
Amy Sciarretto
Big Picture Media
Rabab Al-Sharif
Michael Rothberg
My dogs
Mango Publishing
Emerson College
Monster Energy
Rock star Energy
Warped Tour
Bamboozle
Gary Strack
Brian Froustet
Myself, I suppose

COMING UP AT the COMMON GROUND
L.I.H.C.
at the PWAC

DIE CLASSIC ROCK SCUM ✶✶✶

1170 ROUTE 109 LINDENHURST
LONG ISLAND (516) 957 4757

FRIDAY THE 13th of DECEMBER @ 7PM

epitaph records + FARENHEIGHT 451
H2O
CLOCKWISE
MAXIMUM PENALTY
a kingsize event...$7.00 MOTIVE

SATURDAY, DEC. 7th @ 3pm for $4.00
a benefit for W.B.C.L. youth organization
MILHOUSE the LAST CRIME
PACIFIER + JUDAS ISCARIOT
KILL YOUR IDOLS LEECH IMPLANT

WEDNESDAY DECEMBER 18th 9:00PM
INSIDE, FRANKLIN
HAL AL SHEDAD
support touring bands!
...only five bucks

victory records' BY THE GRACE OF GOD
HANDS TIED (EX MOUTHPIECE) friday december 20th 7:00 PM
TEN YARD FIGHT & MORE T.B.A.

FRIDAY DEC 27: 25 TA LIFE, TENSION,
GRUDGEHOLDER, 141, OUTRAGE, OVERTHROW
SUNDAY DEC 29: ASSUCK, RYE COALITION,
IRONY OF LIGHTFOOT, HOT WATER MUSIC,
JUDAS ISCARIOT, KATAKLYSM (from canada)
NEW YEARS EVE: THE MISFITS!!!

LONG ISLAND'S ONLY ALL AGES, NON-PROFIT,
DRUG & ALCOHOL FREE MUSIC VENUE RUN
TOTALLY FOR THE KIDS AND BY THE KIDS!

About the Author

Taylor Markarian experienced the music wave of the early 2000s firsthand as a teenage fan. While struggling with mental health issues as well as the typical growing pains of adolescence, she found a home in indie, emo, screamo, and eventually heavier genres like metal and hardcore. Markarian followed her passion for writing and music by attending Emerson College in Boston, Massachusetts. In 2014, she lived in L.A. where she interned at punk icon Brett Gurewitz's (Bad Religion) record label, Epitaph Records. She graduated with honors from Emerson College in 2015 with a B.A. in Writing, Literature & Publishing and a minor in Music Appreciation. She has written for many print and online publications including Alternative Press, Kerrang!, Revolver, Loudwire, and Reader's Digest. Markarian was born in New York City. She was raised and currently resides in New Jersey.

Printed in the USA
CPSIA information can be obtained
at www.ICGtesting.com
JSHW051959150824
68134JS00057B/3355

9 781642 501148